Transplant recipient writes children's book

By DANIELLE RUSH Sep 1, 2009

BUNKER HILL — After 76 days in St. Vincent Hospital, waiting for and receiving a heart transplant, Mary Beth Fites wasn't sure how to explain what she had been through to her grandchildren.

On her last day in the hospital, Oct. 26, 2008, she said she felt God speak to her and she began writing a story from the point of view of her grandchildren.

"I got inspired and I sat down and wrote it," in about 90 minutes, she said, and called her children's book "Race Me Grandma."

Then, she wanted to put it in a nice format with pictures, to give to her grandchildren. She first looked at having it professionally illustrated through a publishing house, but found that was too expensive. Then, she thought of the offenders at the Miami Correctional Facility, where she is an account clerk with the offender trust, which handles the offenders' internal accounts.

She learned that offenders in the Purposeful Living Units Serve Plus program are required to provide 320 hours of community service to complete their program. She made a request to the superintendent and the administration in the central office of the Indiana Department of Correction.

Administrators agreed offenders could illustrate Fites' book as long as they did not profit financially. Jeffrey Wines and Nicholas Liss each read her story and provided a complete set of drawings for it.

Fites, a Miami County resident, said she was thrilled to see the finished copy with Wines' drawings. She has not yet printed the version with Liss' drawings.

"The pictures are what really draw them to it," she said.

Wines said the PLUS program chaplain asked him if he wanted to participate, and he's enjoyed drawing his whole life. He's found drawing to be a way to pass time, and he also illustrates cards and envelopes.

He was moved by Fites' story, particularly because he has a family member who has been sick.

He read the story and Fites' list of ideas she had for the illustration, then began work, completing about a page a day.

"I knew what she was trying to say to her children," he said. "I thought it went pretty good. I was impressed with myself."

His version features Fites as a white-haired grandma. Wines said he and Liss each used their own art supplies.

Liss depicted Fites in a more modern way, as a "super grandma" with large muscles.

"I've never done anything like a children's book," Liss said. "I took it as a challenge. I thought it was cool."

He is an artist and does illustrations, tattoo design and computer illustrations. He thinks having illustrated a children's book will help him when he completes his time in prison.

Fites said it was a touching moment when she first saw the completed book, printed and bound by Modern Graphics.

"Everyone in the business office just kind of cried. [The drawings] made the words come alive."

She handed out copies to family members, and word began to spread. Soon, requests came in for more copies. She first printed 100 books at a cost of $800, and those books were gone in less than three weeks. Fites has sold about 400 books so far, and takes orders by request. Books are $10 each.

She's donating the proceeds to St. Vincent Sharing Hearts, which helps transplant recipients who cannot afford the medication they must take after a transplant.

The Indiana Organ Procurement Organization also ordered copies for its educational programs, Fites said.

She recently sent a check for $1,200 from book sales.

Fites added that she's exchanged letters with the mother of the 19-year-old man whose heart she received, through the organ procurement organization. She's not allowed to exchange full names or any other identifying information until the one-year anniversary of her transplant, because it gives the donor's family time to grieve their loss. Fites said the mother knows she has written a book and has requested a copy. She can send one now with her name blacked out, or wait until October to send it with her name on it.

She said the transplant team at St. Vincent Hospital is researching how it can use her book as a teaching tool, and are also helping her look for grants to have the book published again with Liss' illustrations.

Fites feels she's already fulfilled her mission with the book.

"Not only did I want children to understand about transplants, I wanted to let others know how God can and does work in your life. He allowed me the peace that passes understanding that the Bible talks about. How can a person sit and wait for someone else to die so that they can live, or many there never will be a heart that is right? You have to be prepared either way. That is not always easy to wrap your mind around. I always said that I couldn't lose. If I lived, wonderful, but if no heart was available and I died, then what better thing than to be in heaven with Jesus. There is no way I could have gone through this experience without him."

Her grandchildren, for whom she wrote the book in the first place, have enjoyed reading it, she said, and have a better idea of what it means to have an organ transplant.

"I just wanted them to understand what it meant, and that someone died. It's been an awesome experience, and I just wanted to give back."

To request a copy of "Race Me Grandma," call Fites at (574) 382-2759 or e-mail marybethfites@aol.com.

• Danielle Rush is the Kokomo Tribune education reporter. She can be reached at (765) 454-8585 or danielle.rush@kokomotribune.com.

Gematria Calculator

liss | Calculate Gematria

(Type in a word or a number e.g. God, Devil, 100, 666 - To calculate gematria values) -

Liss in Jewish Gematria Equals: **209** (l i s s / 20 9 90 90)

Liss in English Gematria Equals: **354** (l i s s / 72 54 114 114)

atria Equals: **59** (l i s s / 12 9 19 19)

יהוה **Results by Jewish Gematria**

Word	Jewish G			Word	Jewish G	
Dor E Lil La	209	Baal Of Hamon	China And Indian	Jason	781	
Cameron	209	Romance	Ufc116	Dragon	182	
Lions	209	Bad Books	Bar Refaeli	Elenin	119	
That	209	Due	Diamagnetic	Sheol	173	
Married	209	Hard Cheese	Noel Callahan	Negro	182	
Nba Finals	209	Bug	The Breed	Slave	816	
Ufc	209	Morôni	In Iraq	Shiva	808	
Tobacco	209	Scream	Blondie Call Me	Tiger	201	
Modern	209	Life Path	209	Cipher	165	
Faction	209	Dream Logic	209	Obamacare	173	
Florence	209	Black Holes	209	Mahabone	137	
Scales	209	Enneagram	209	Euro	335	
			354	59	Chokmah	110
				Eminem	119	
				Spain	200	
				Double	281	
				Crow	1033	
				Jonas	781	
				Keter	200	
				Third	201	
				College	110	
				Accident	165	
				Aryan	522	
				Credit	201	
				Merkabah	137	

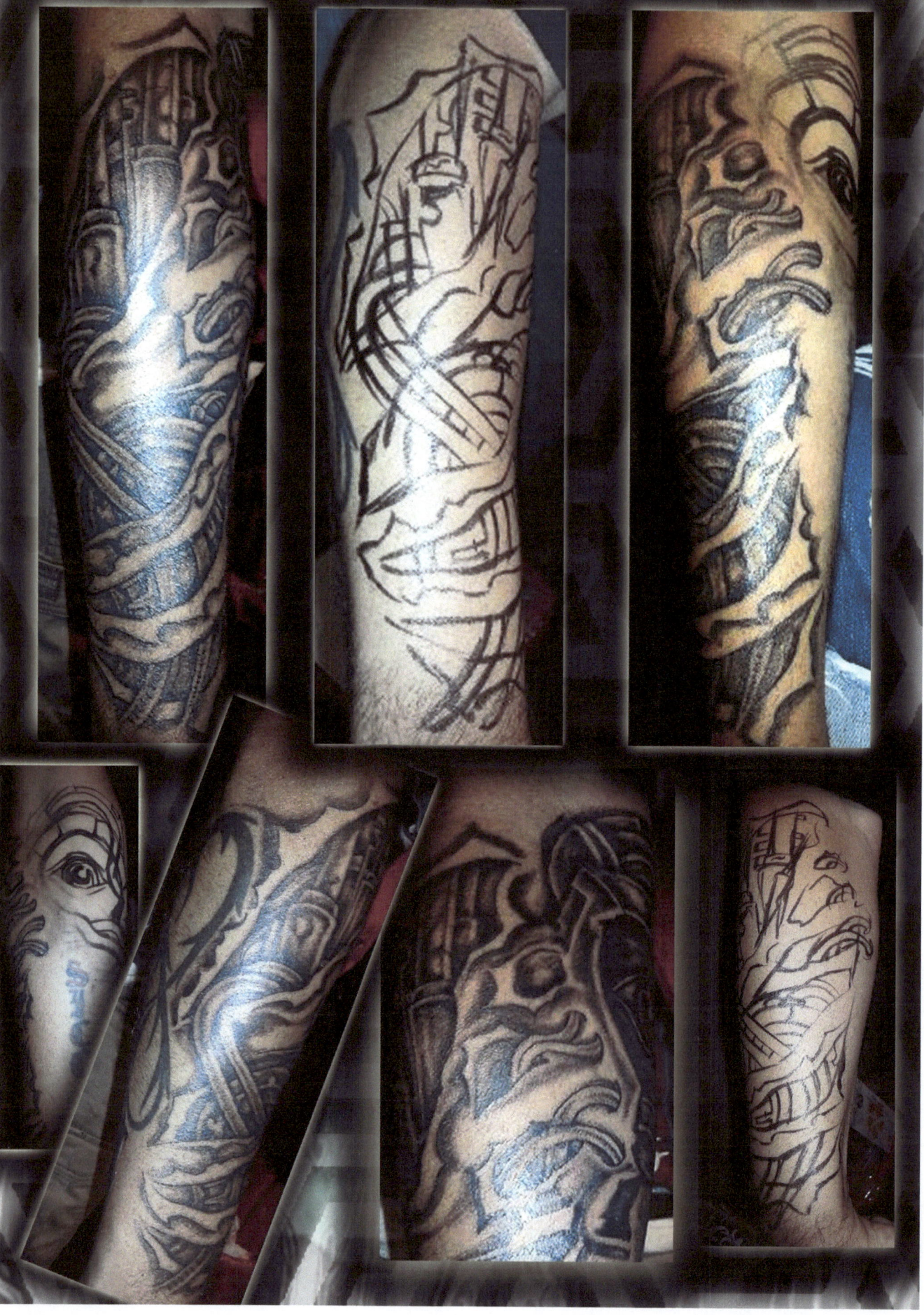

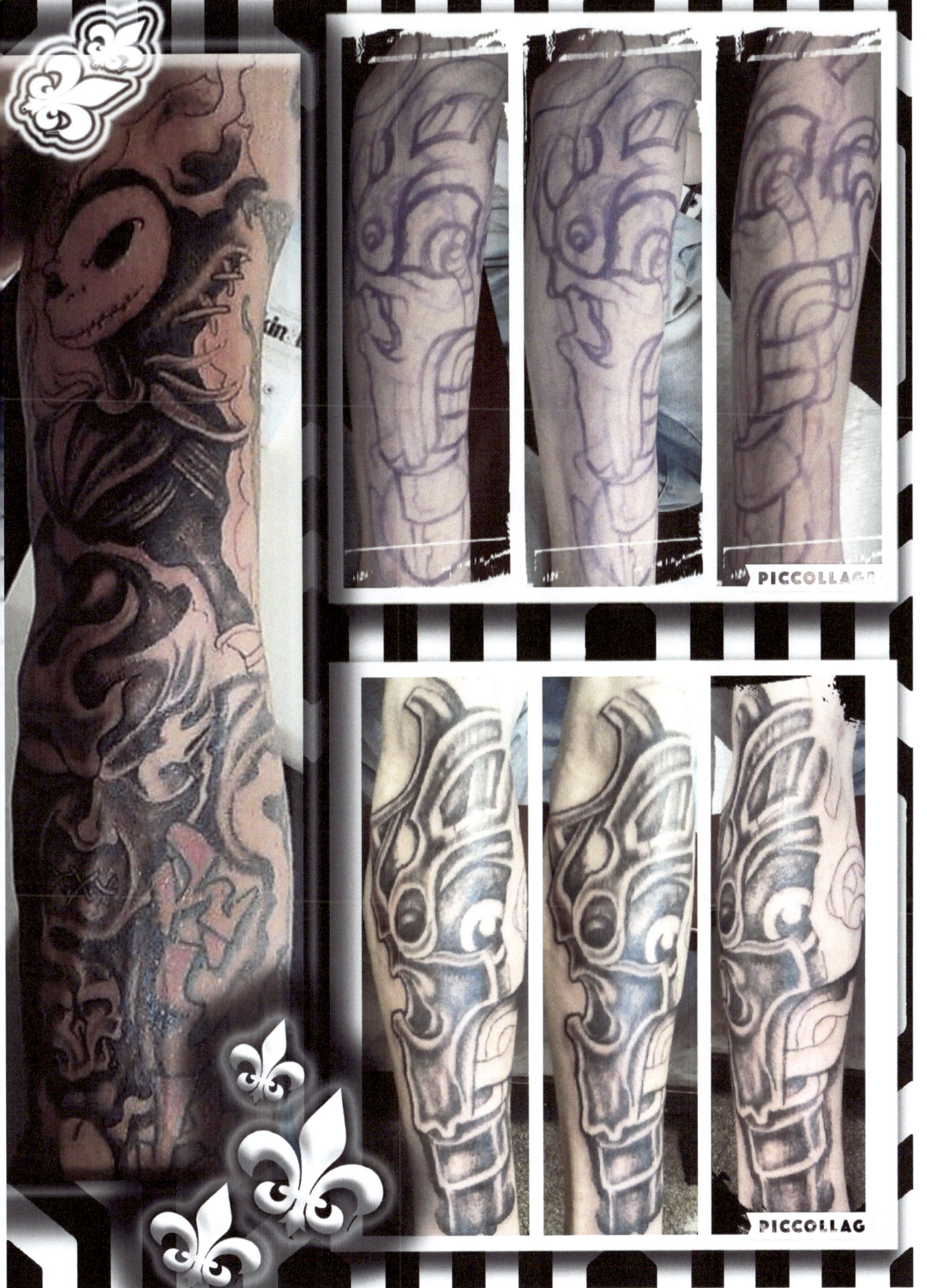

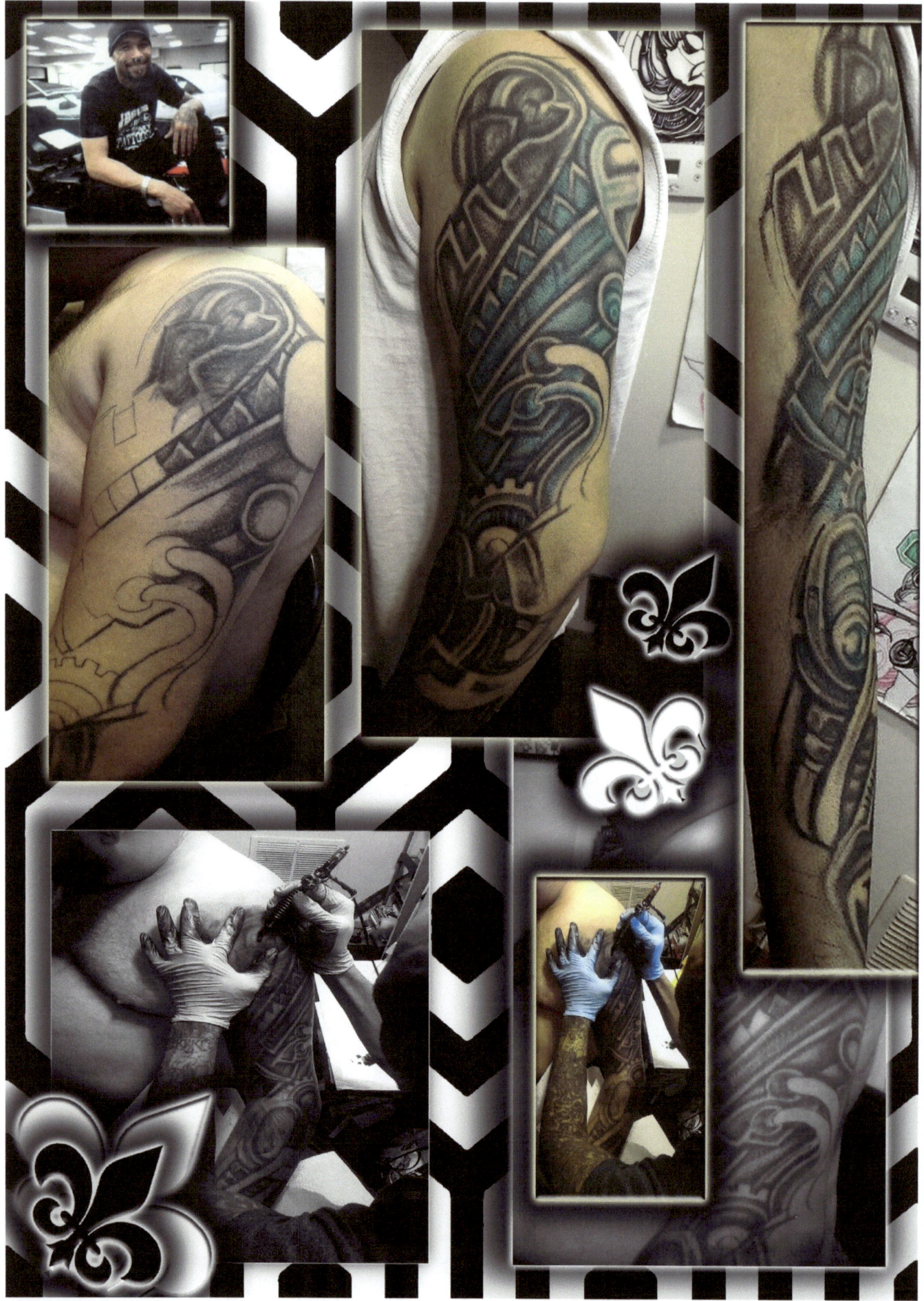

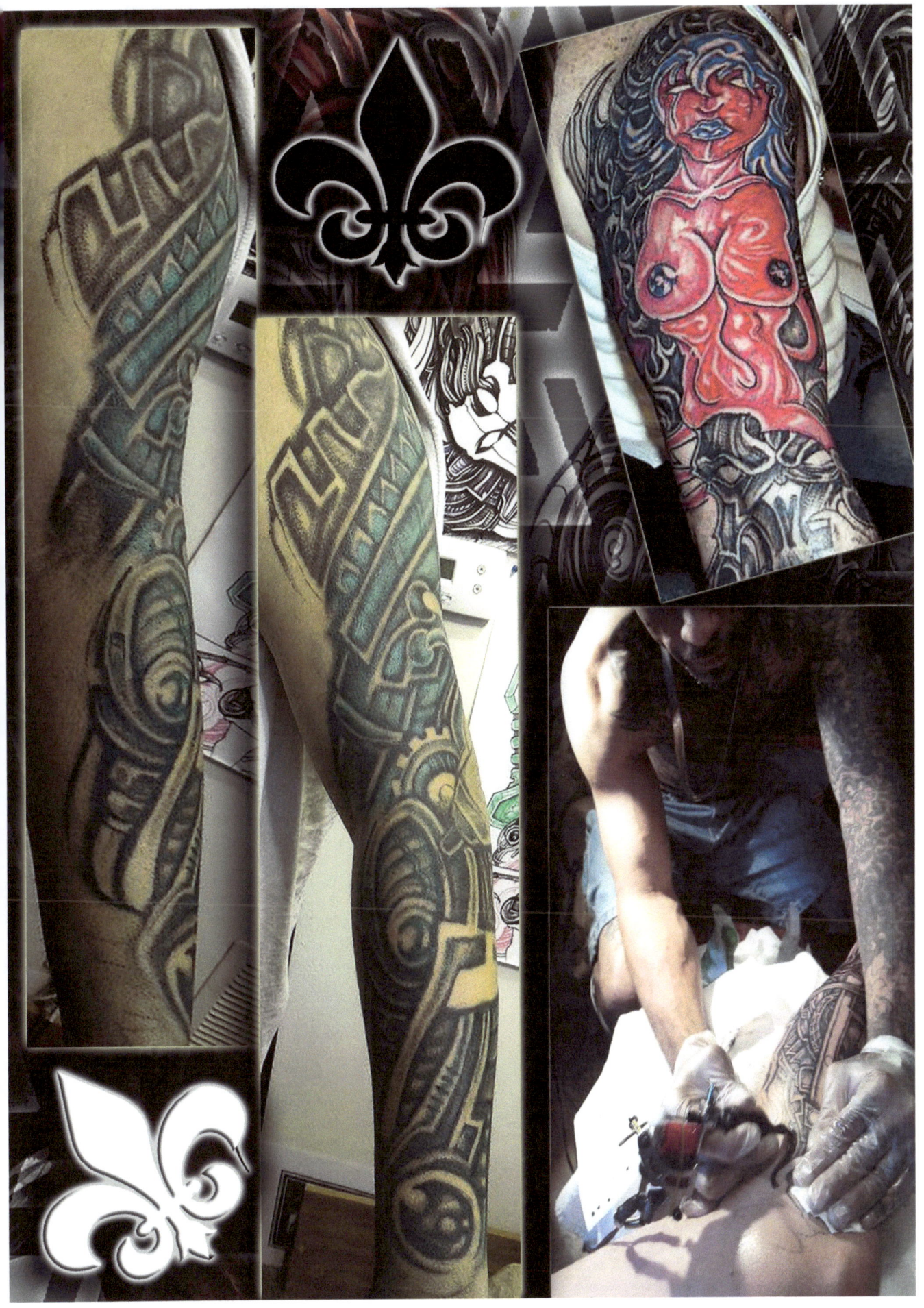

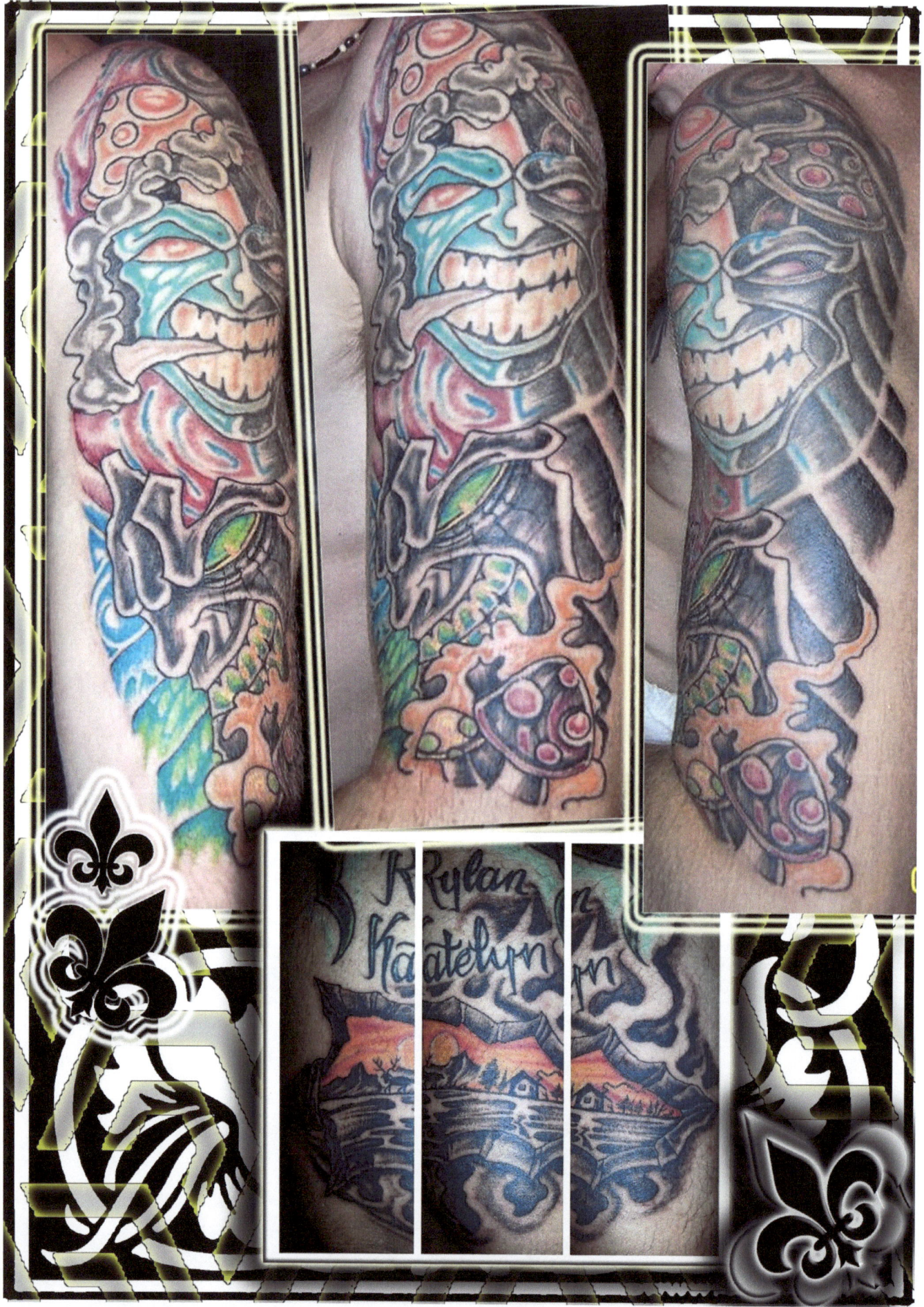

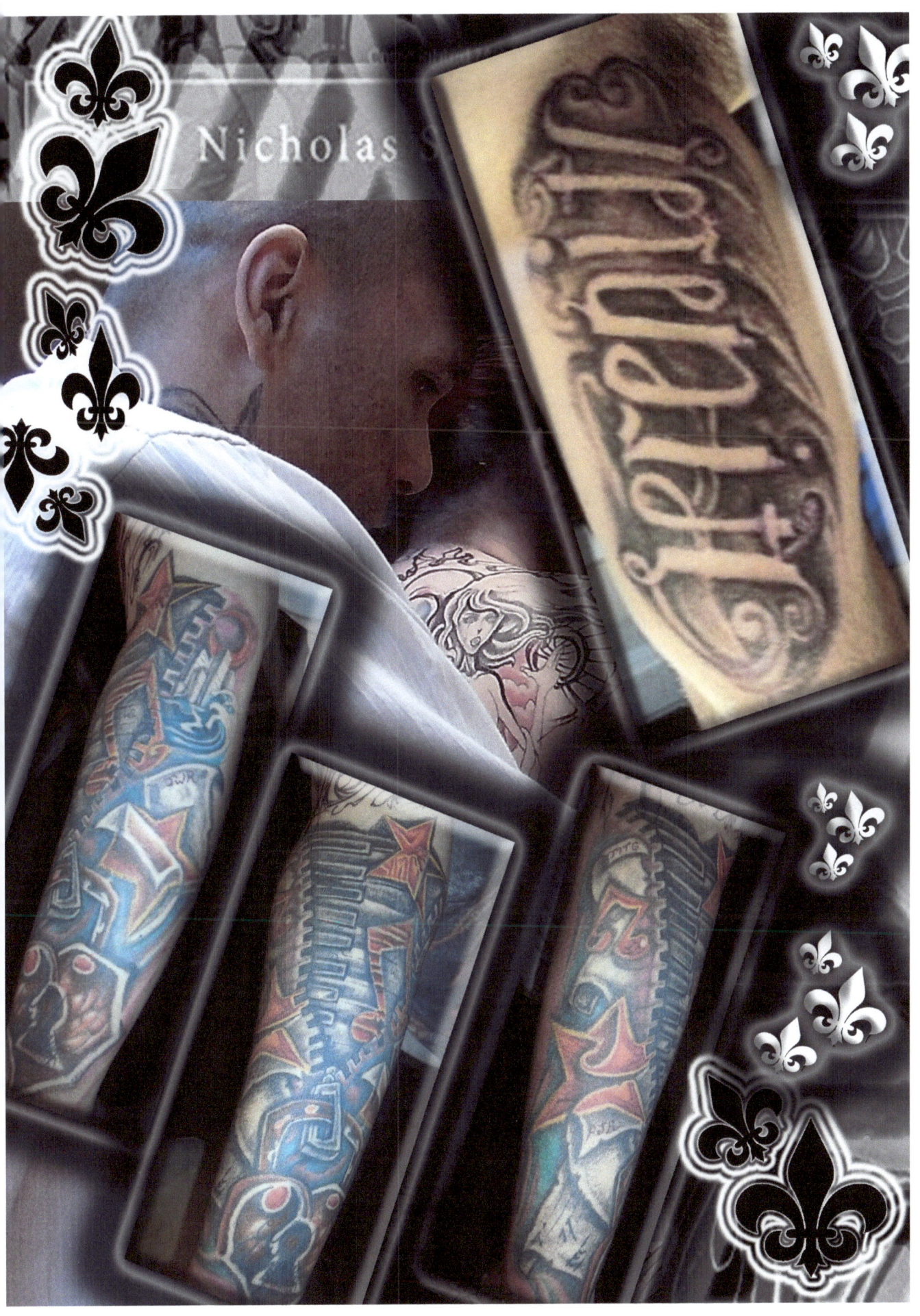

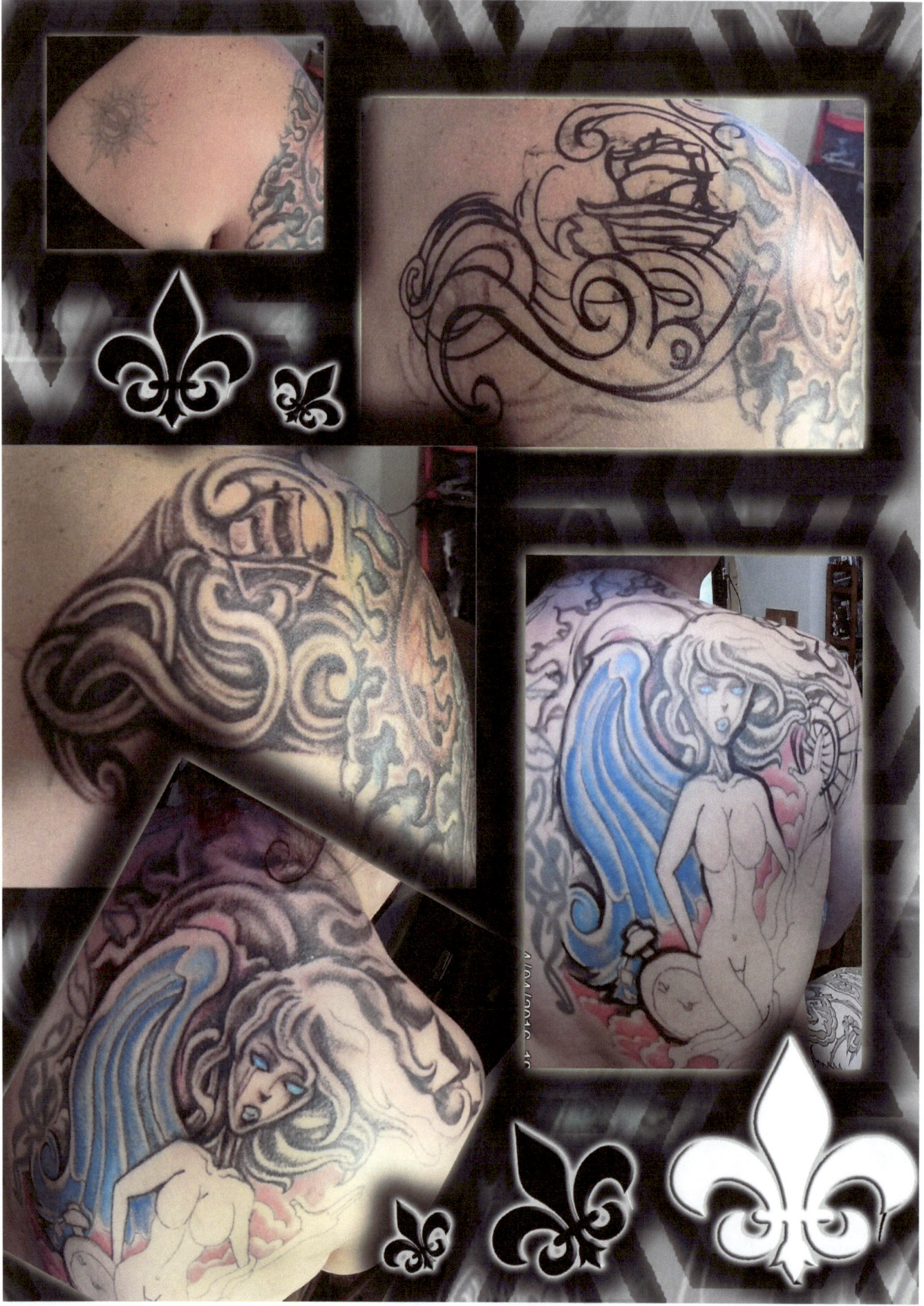

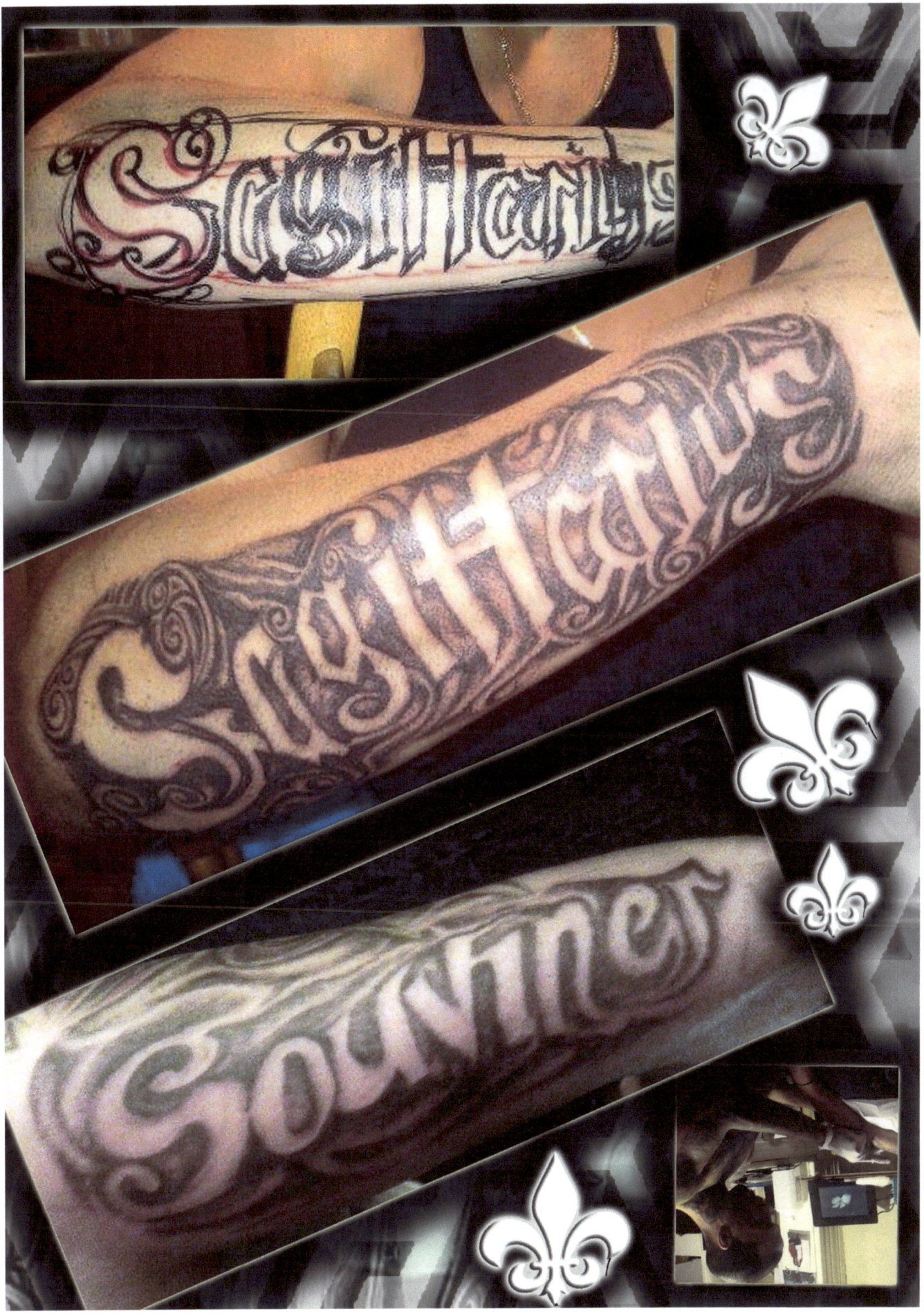

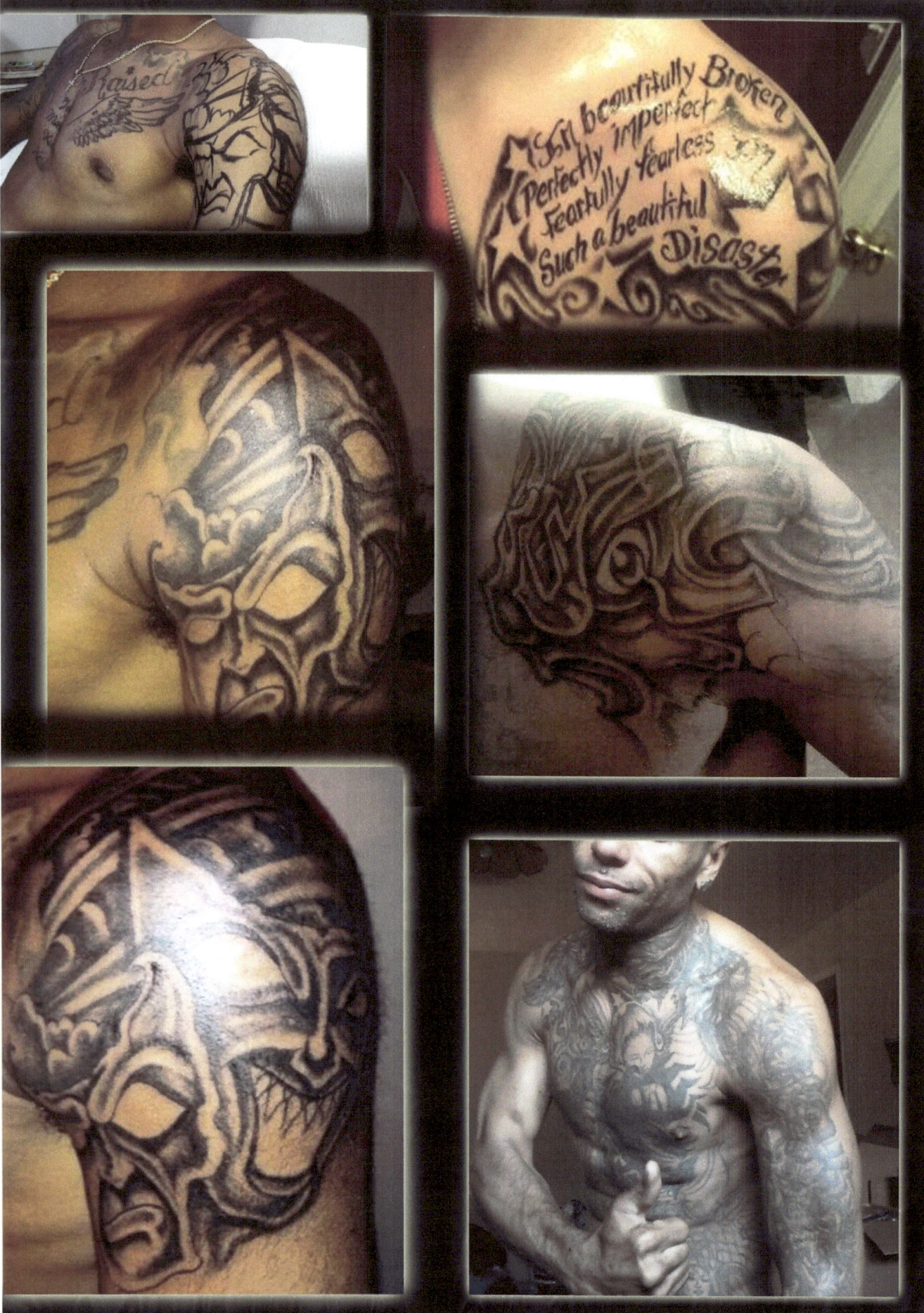

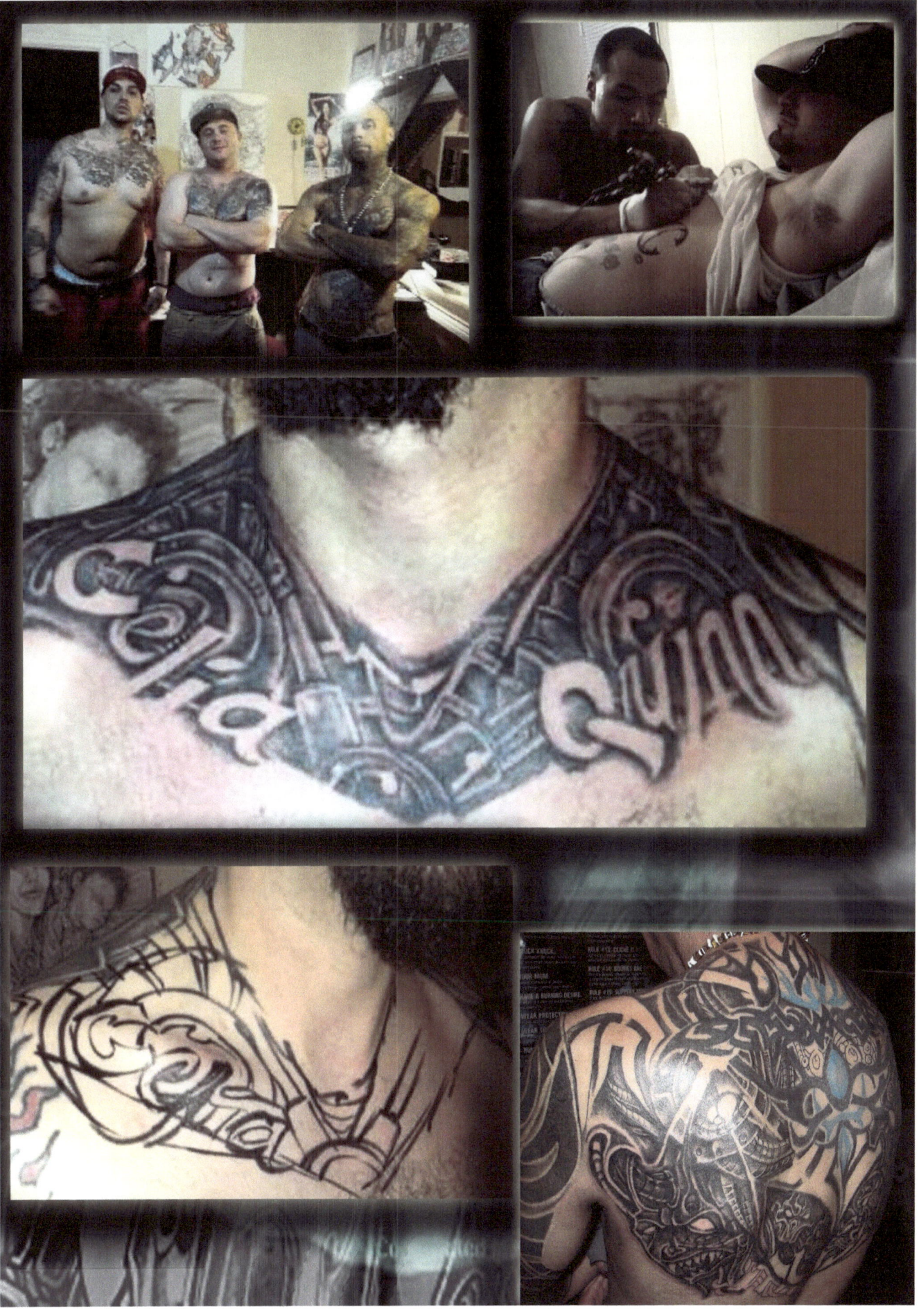

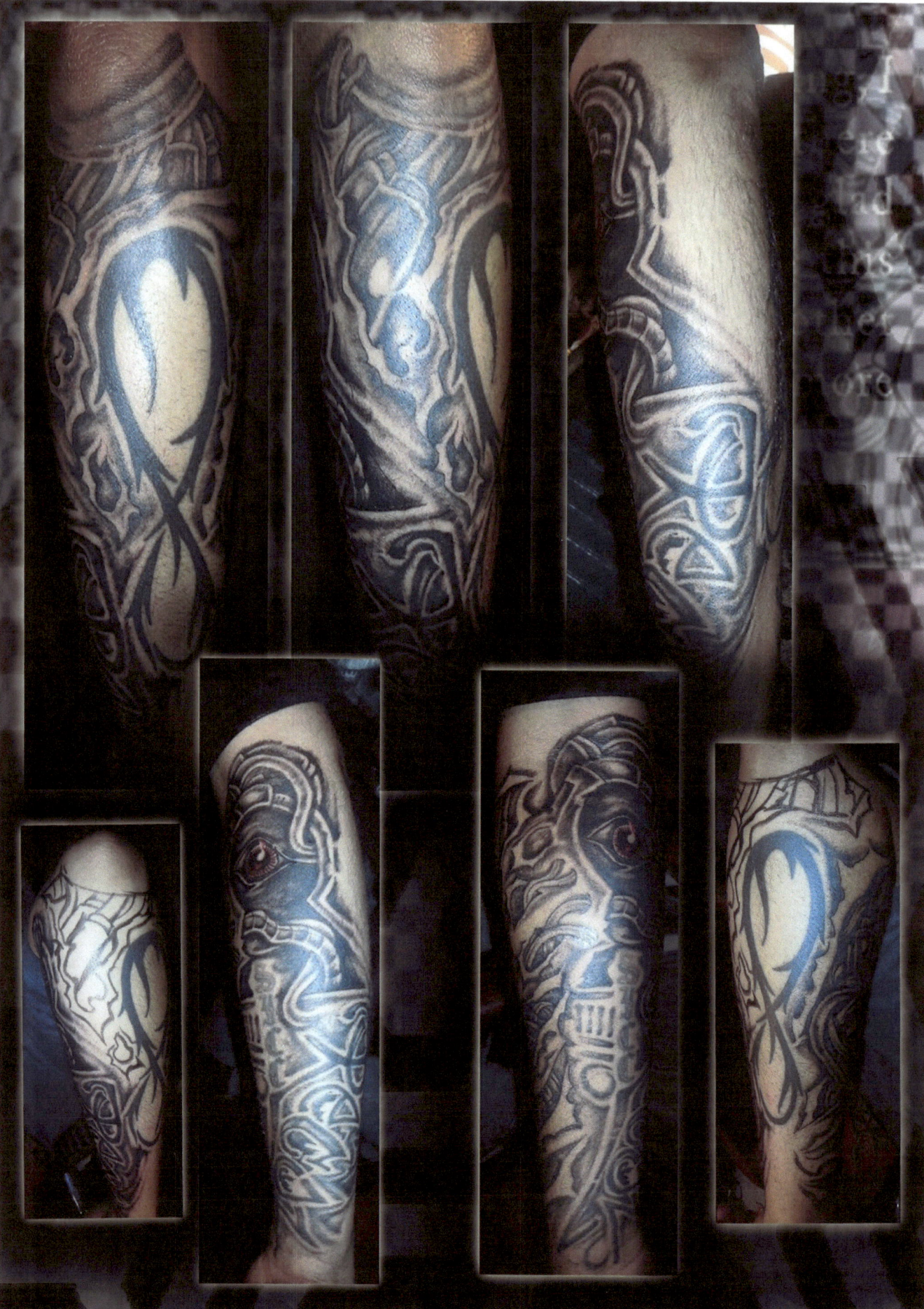

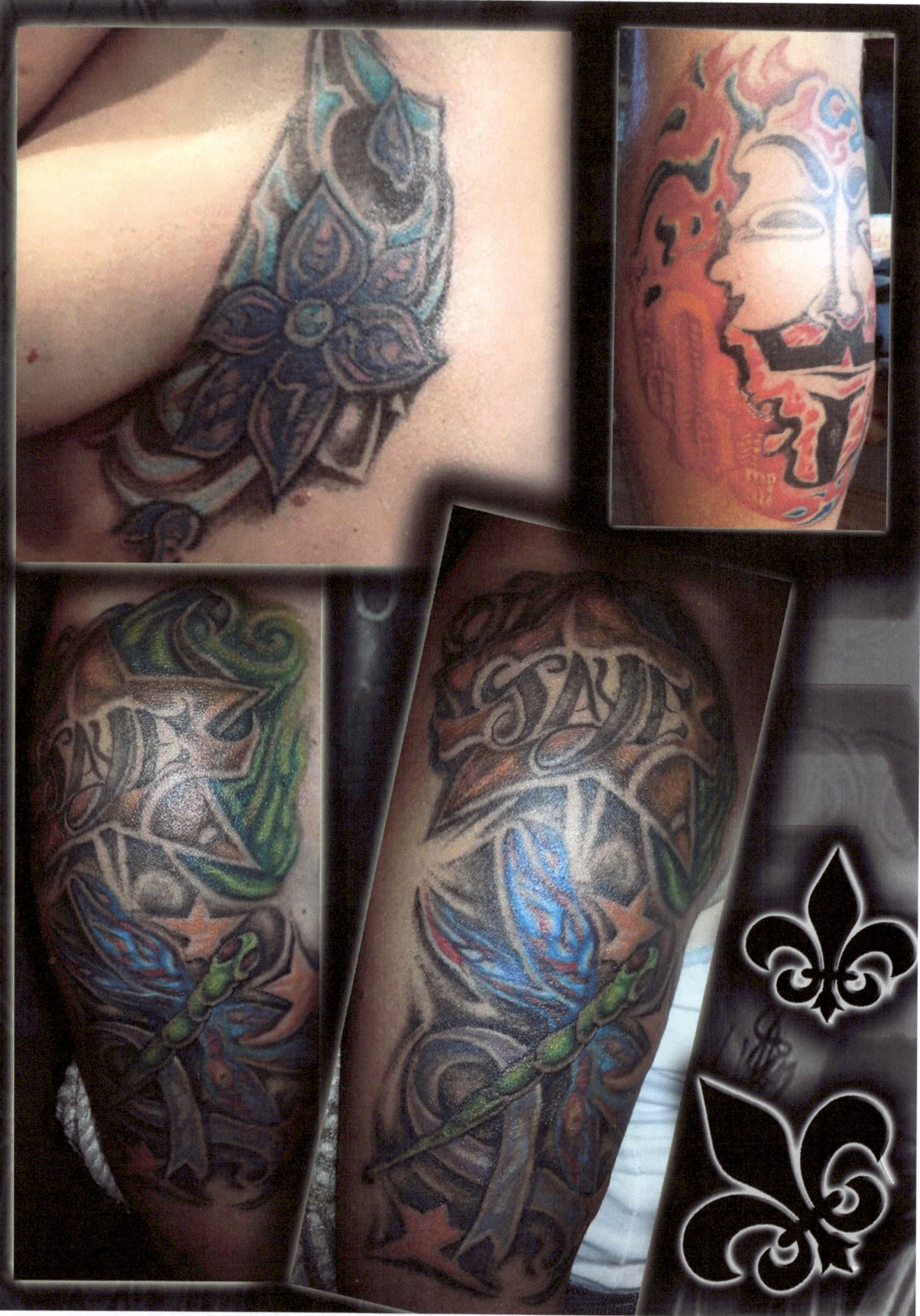

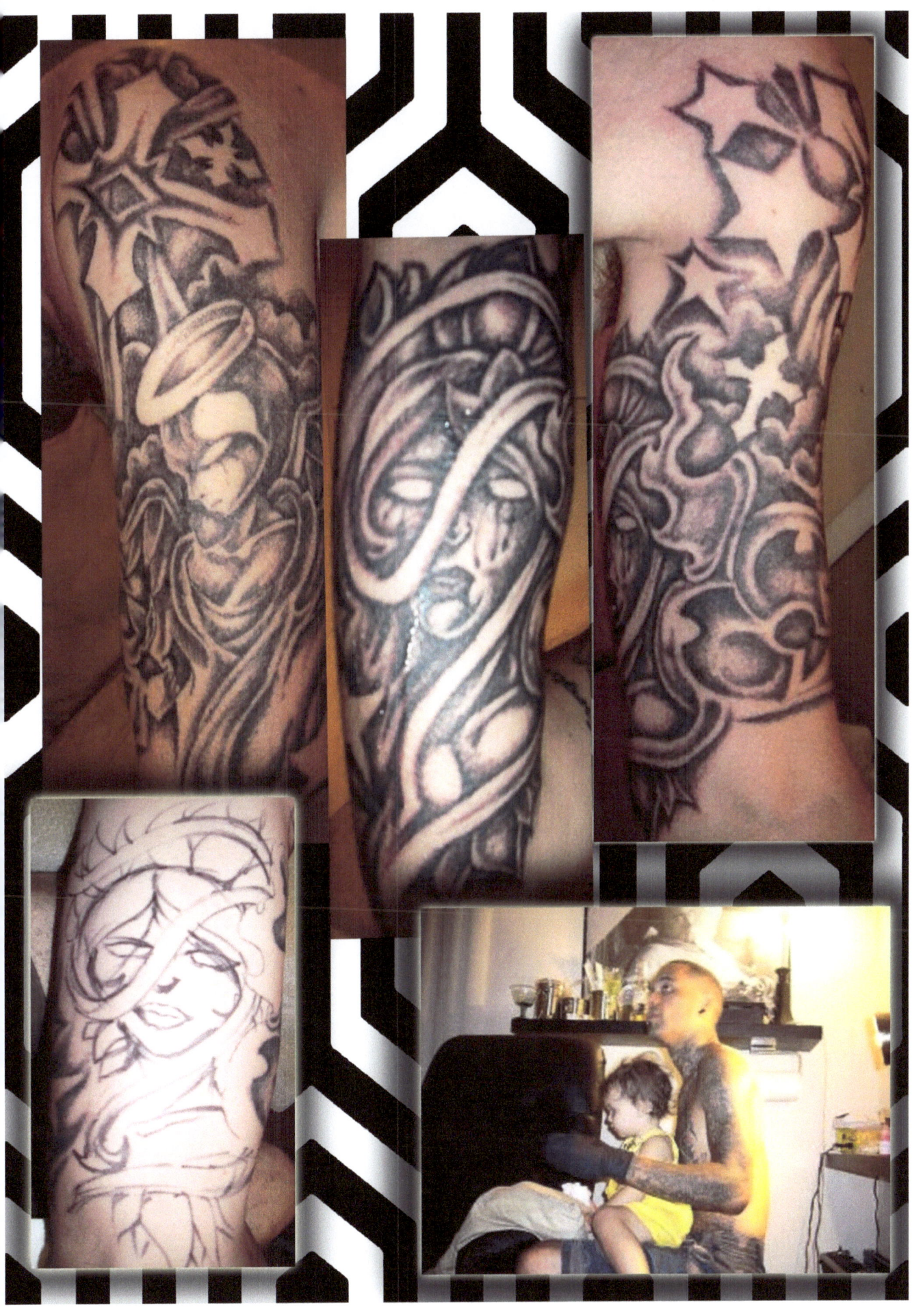

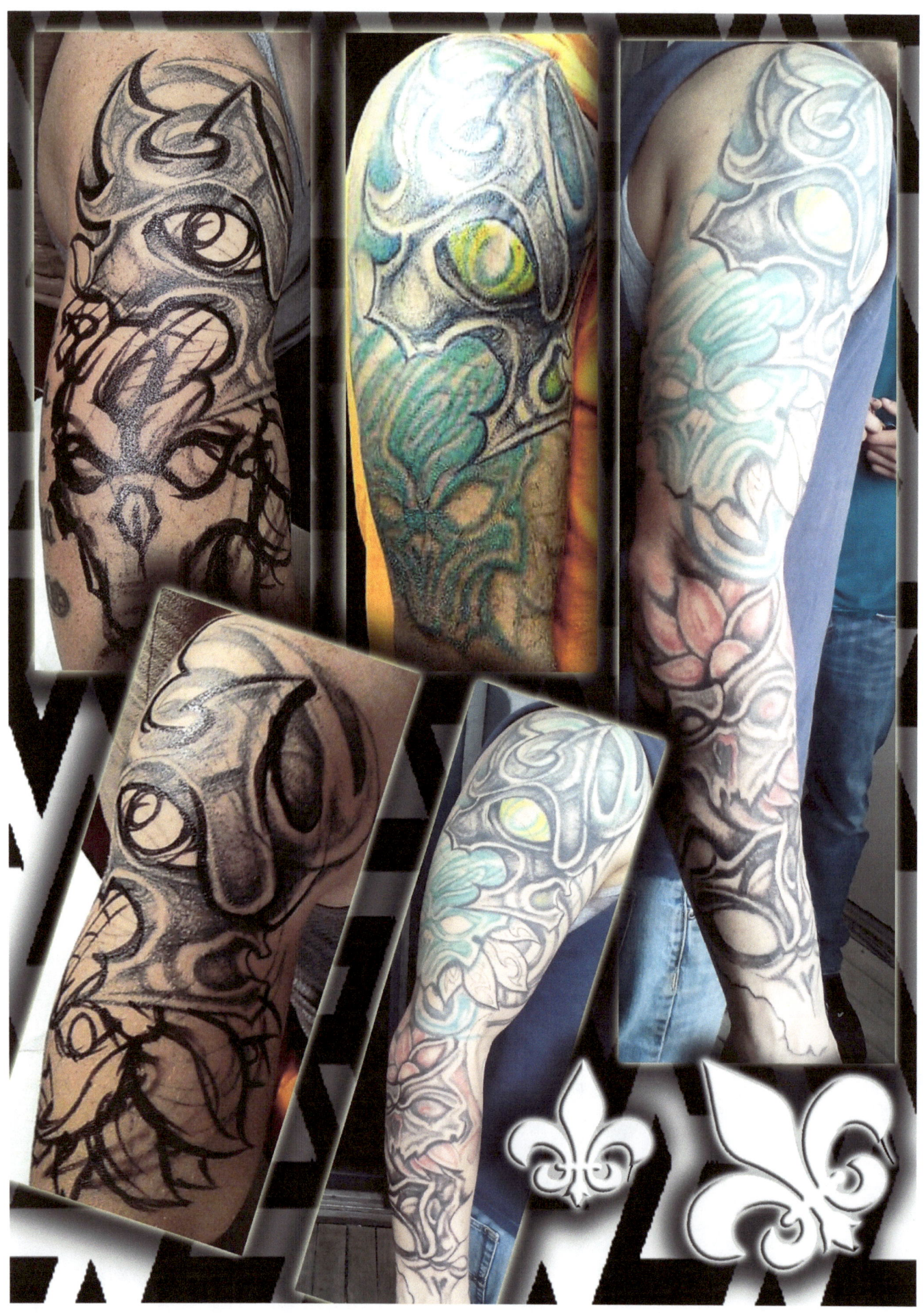

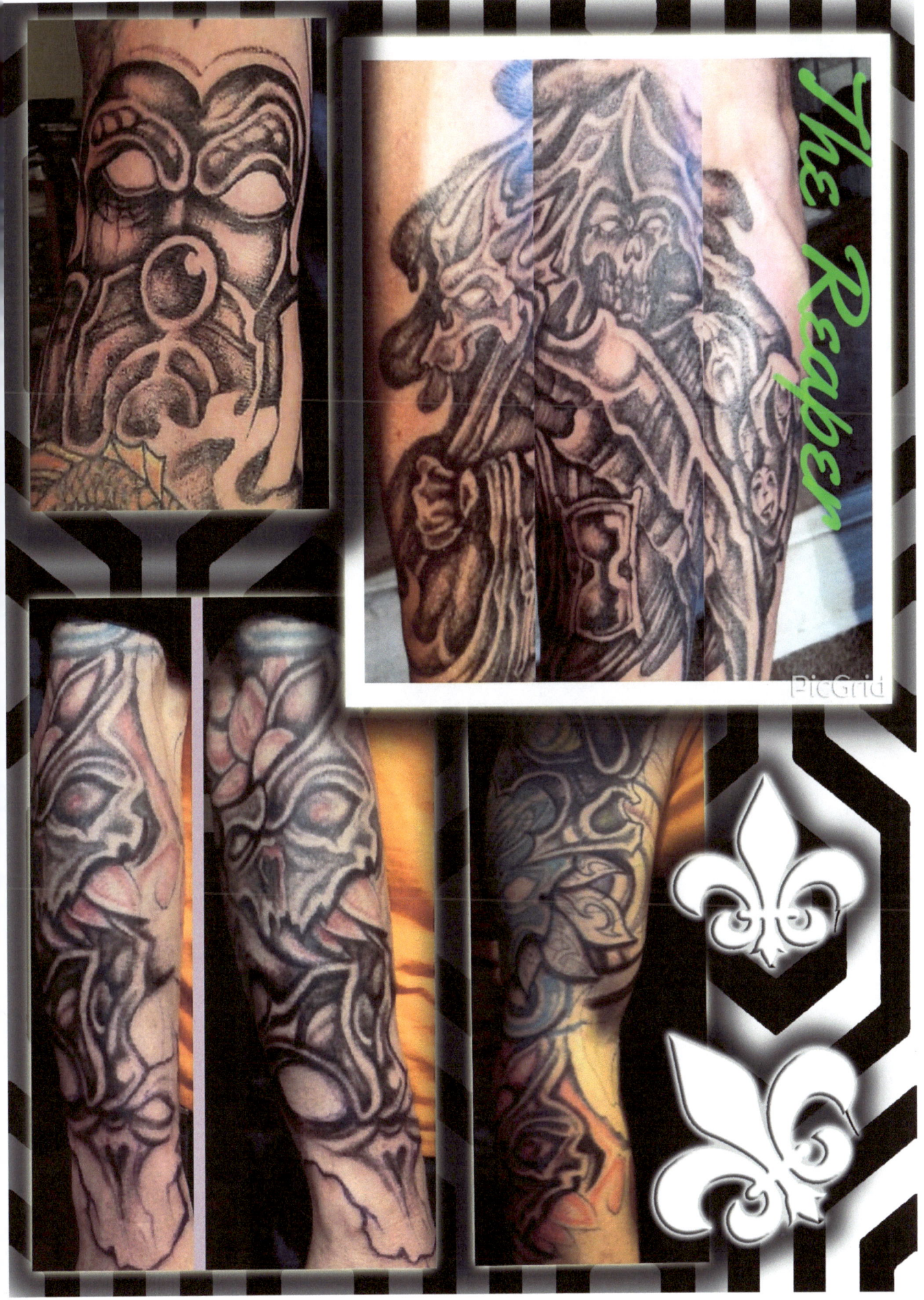

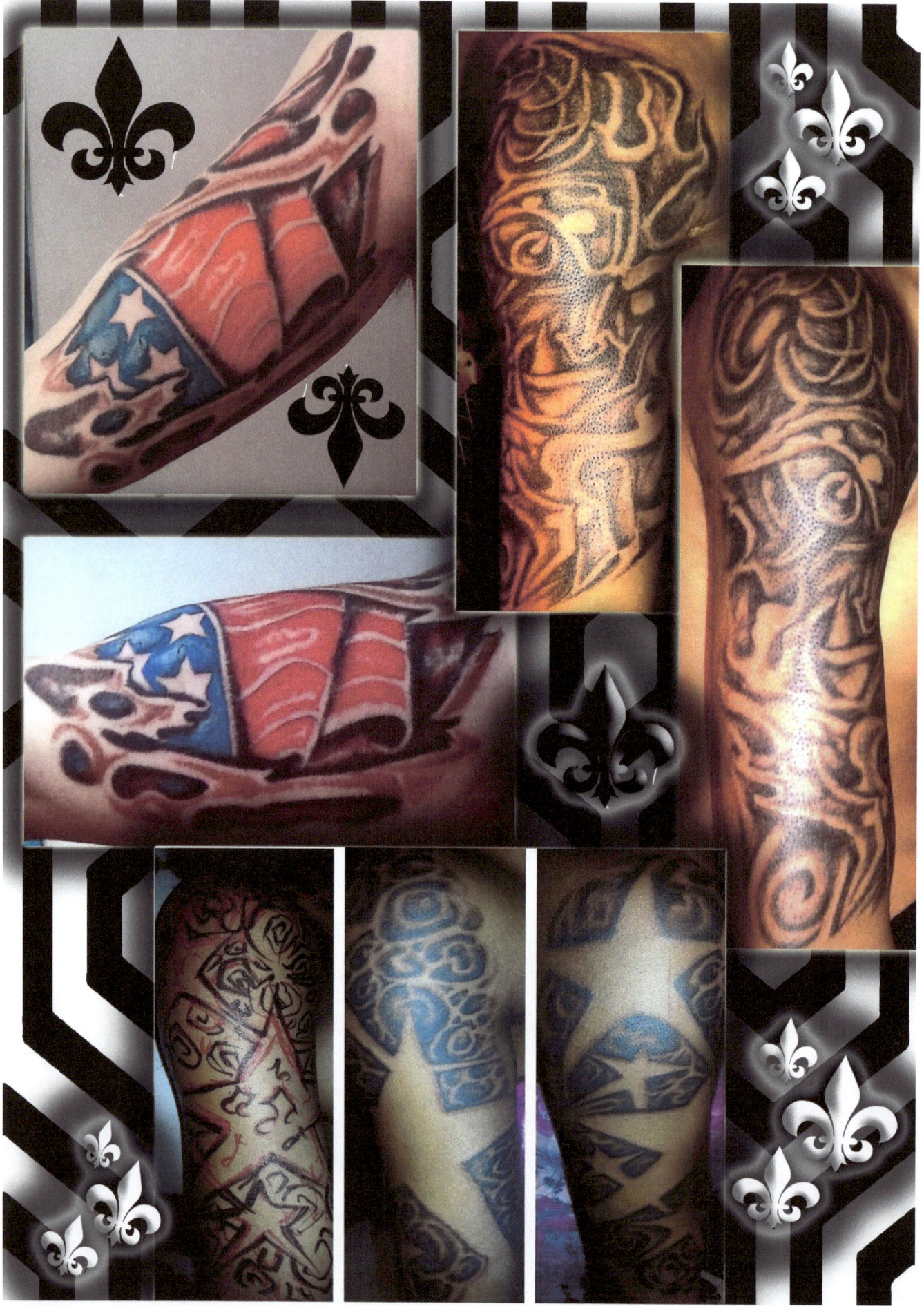

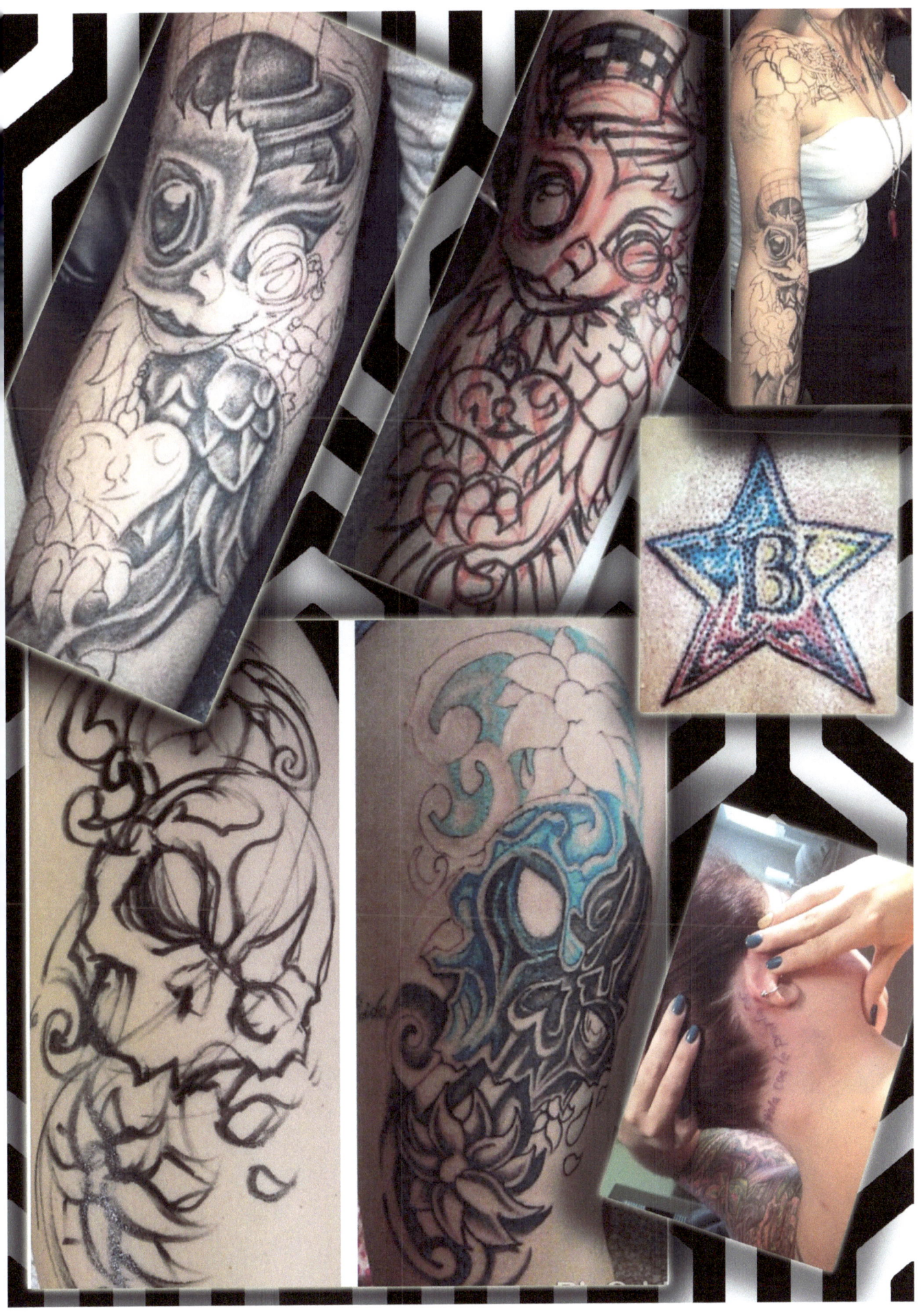

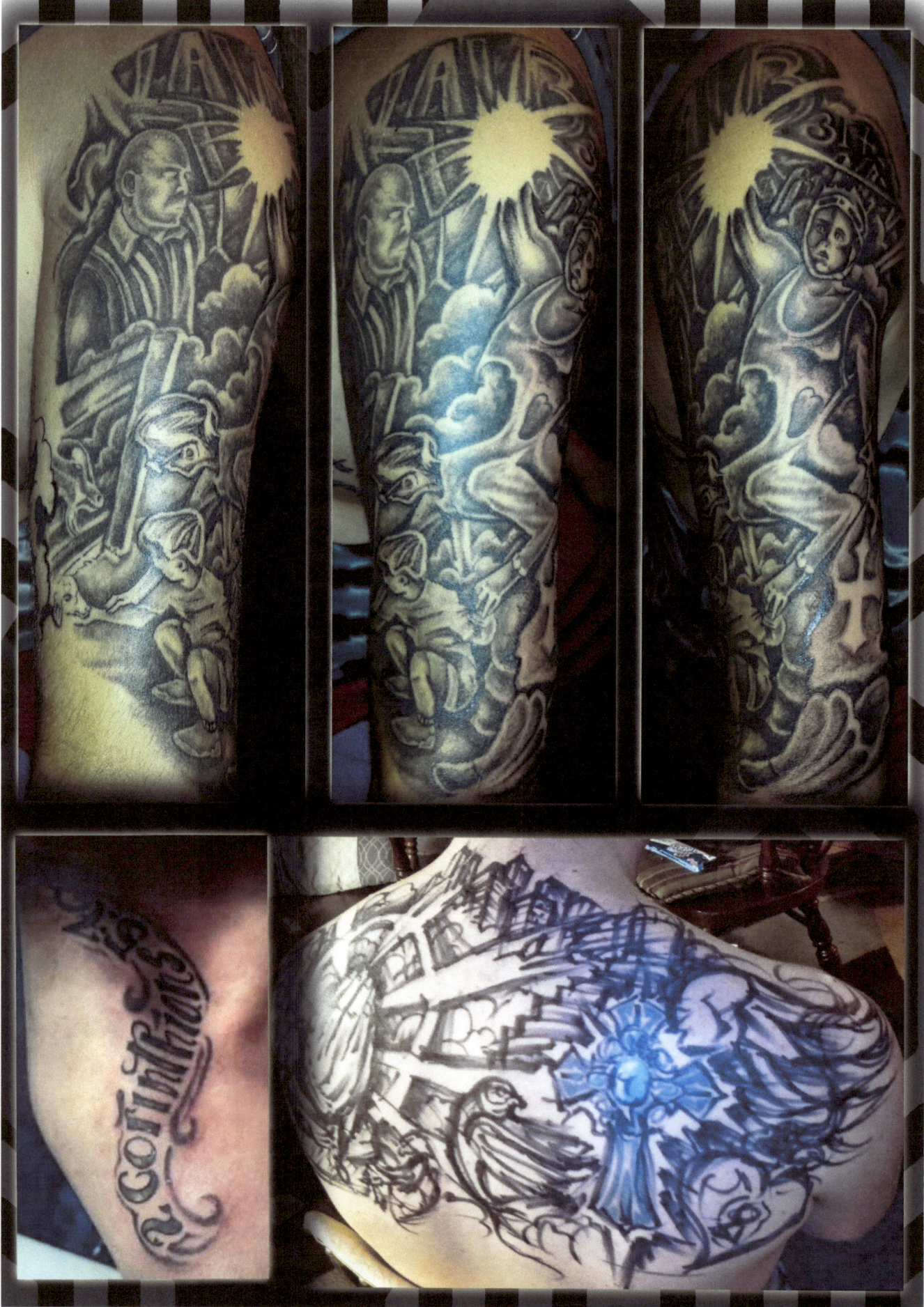

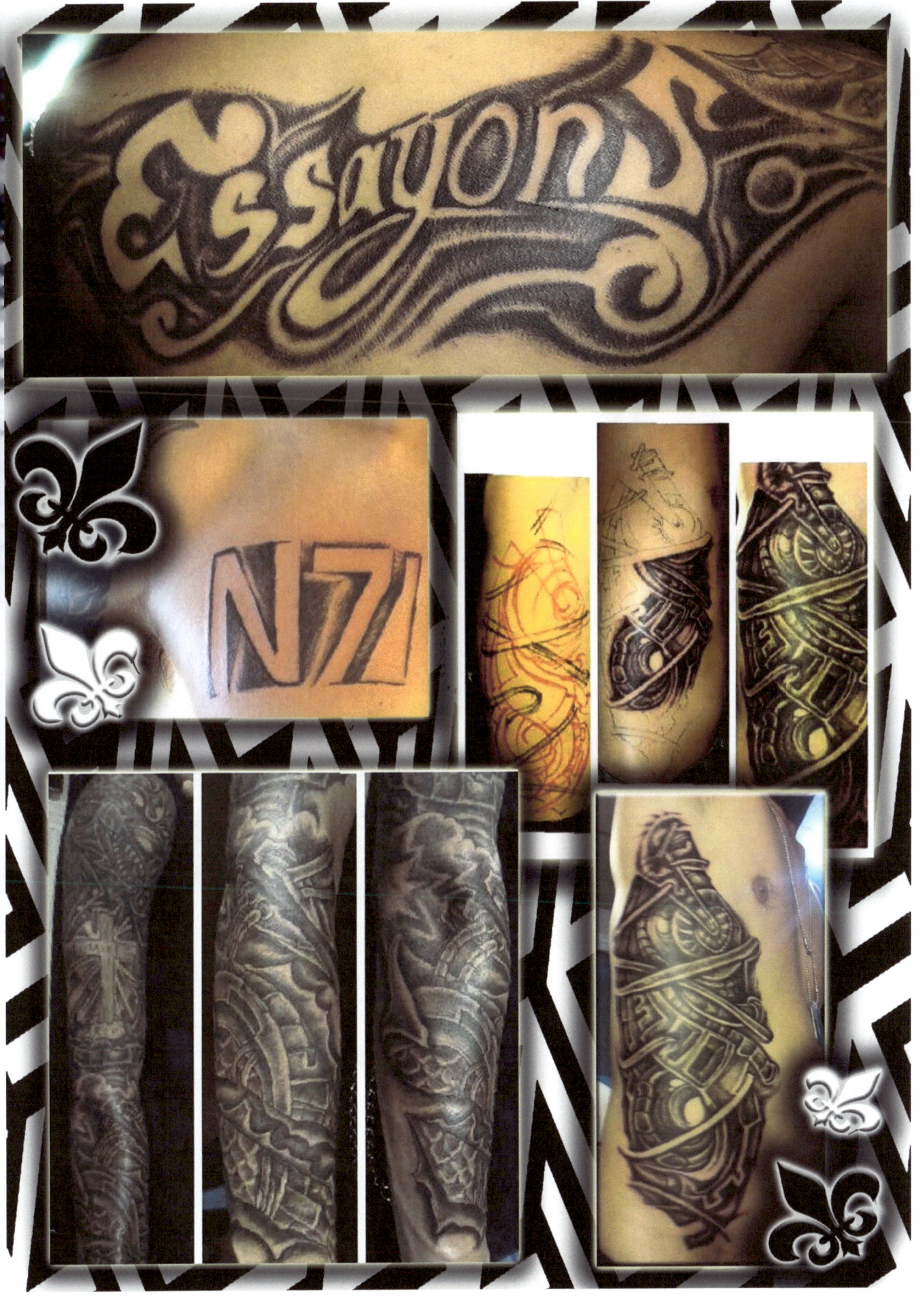

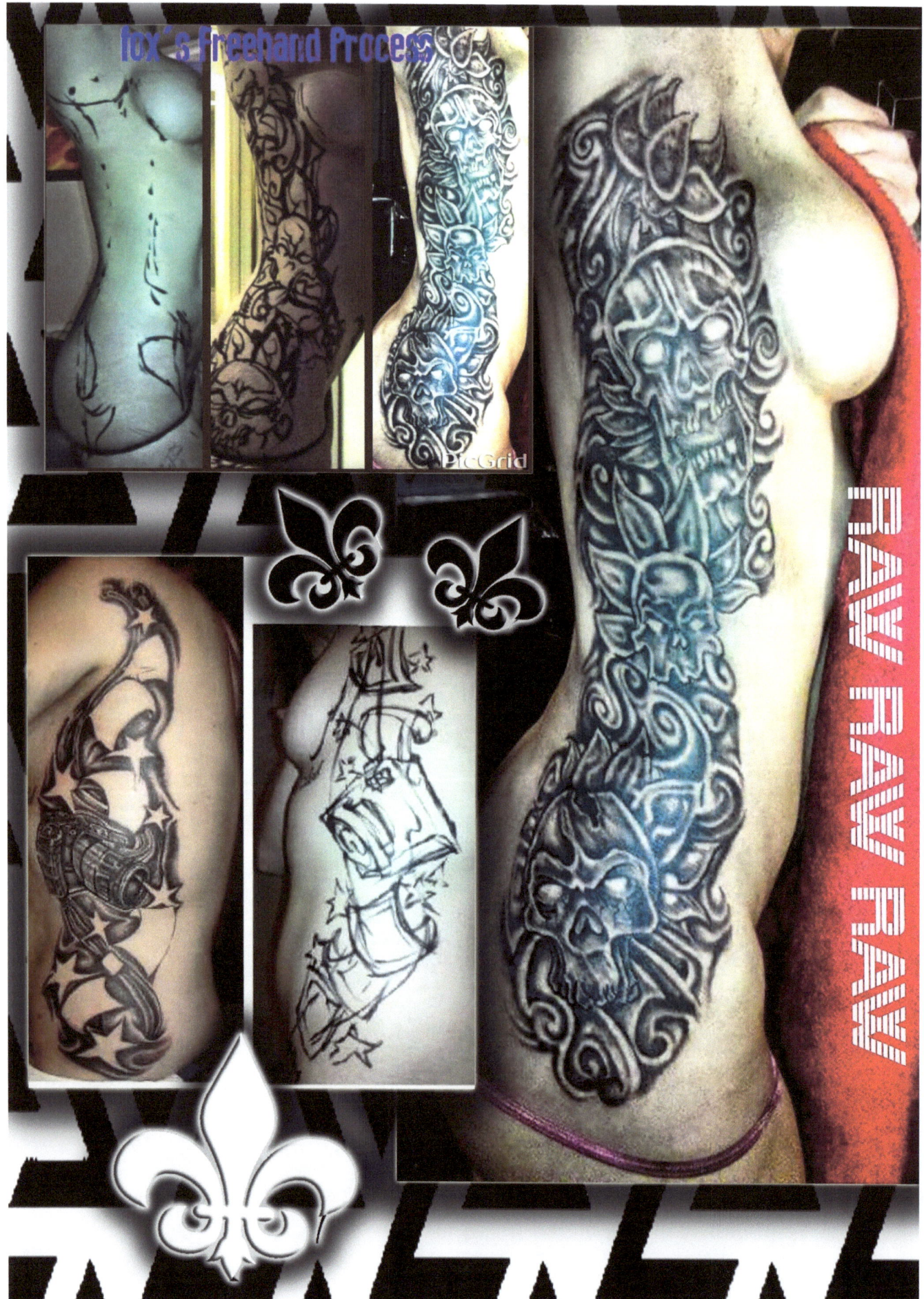

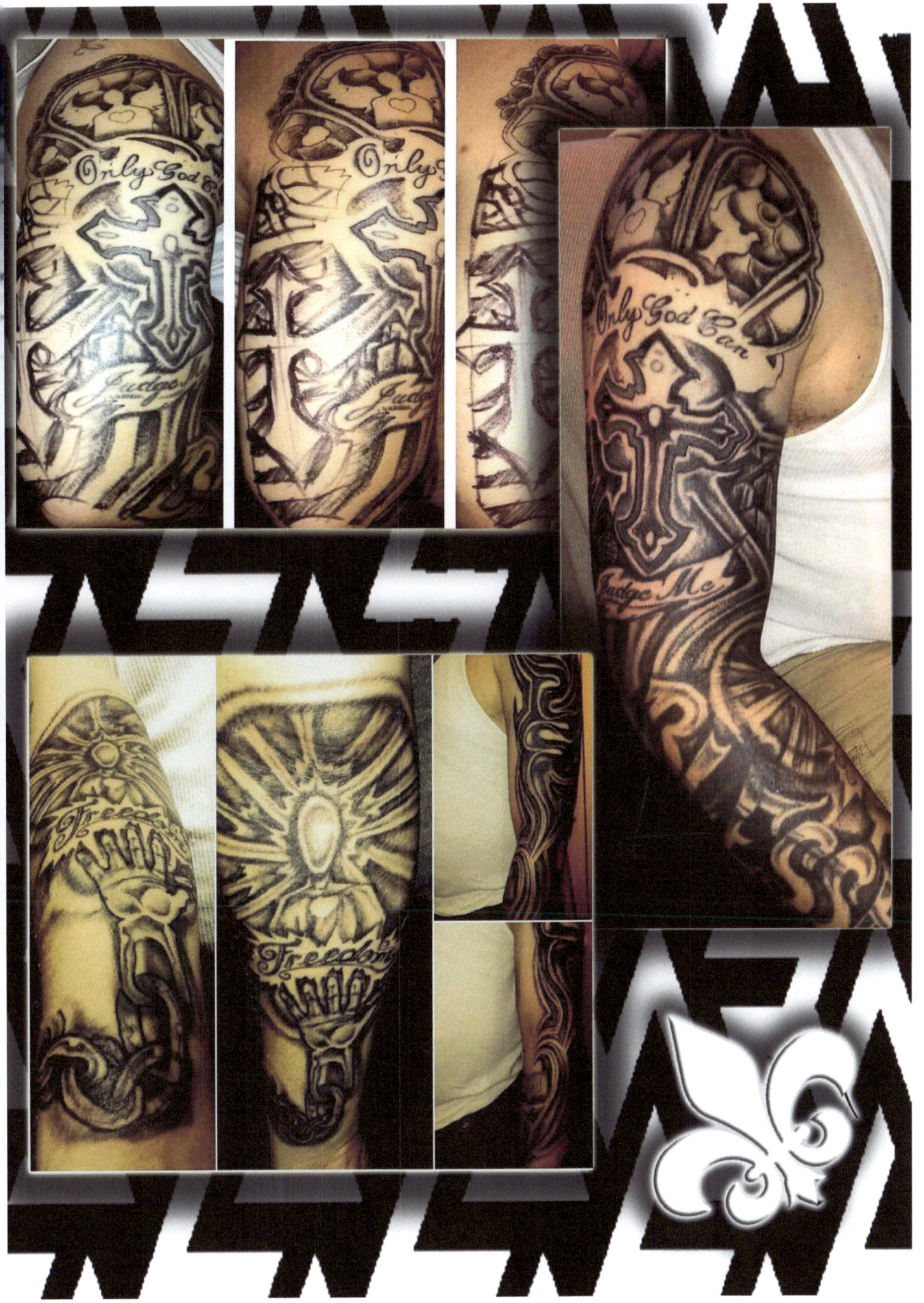

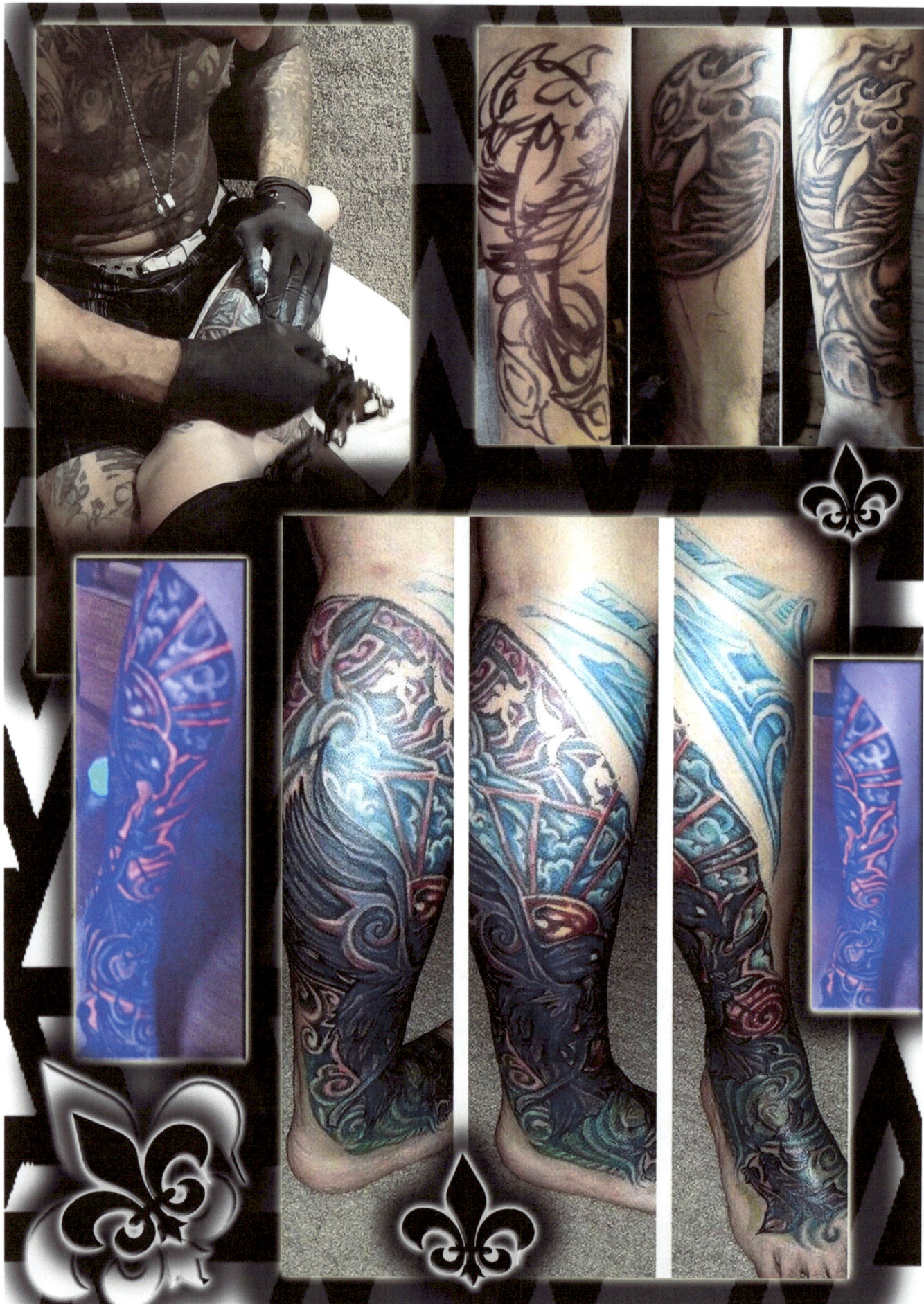

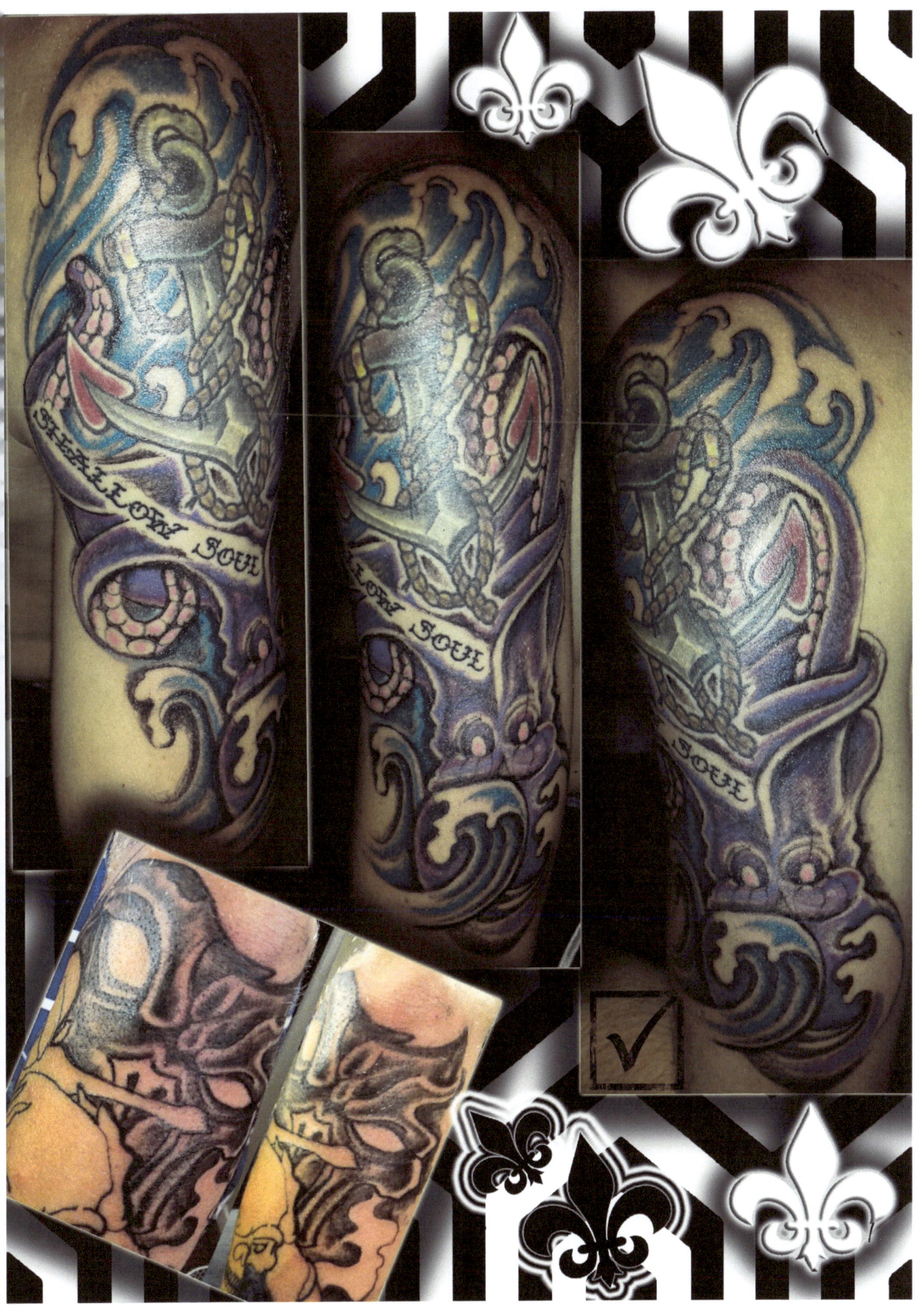

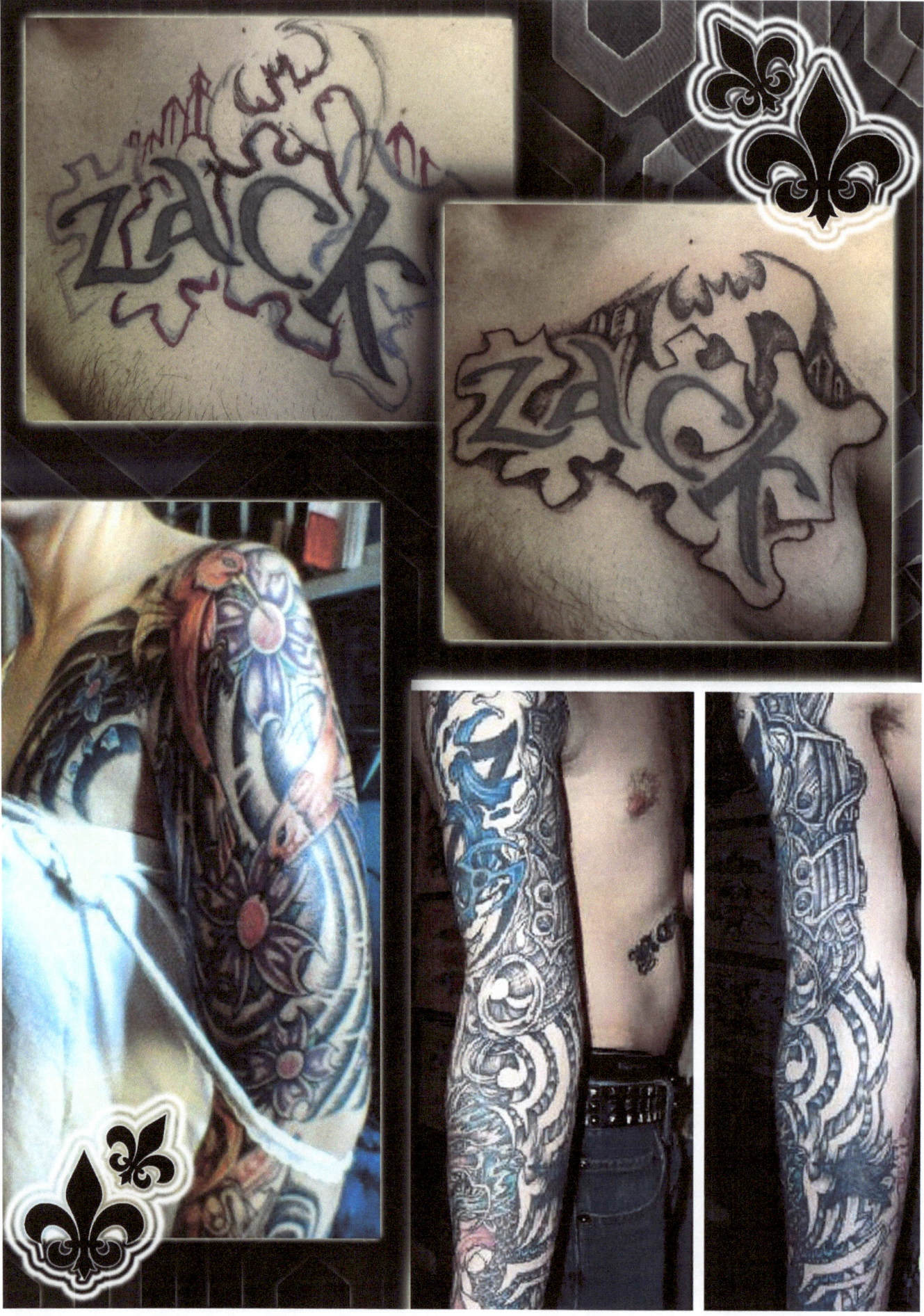

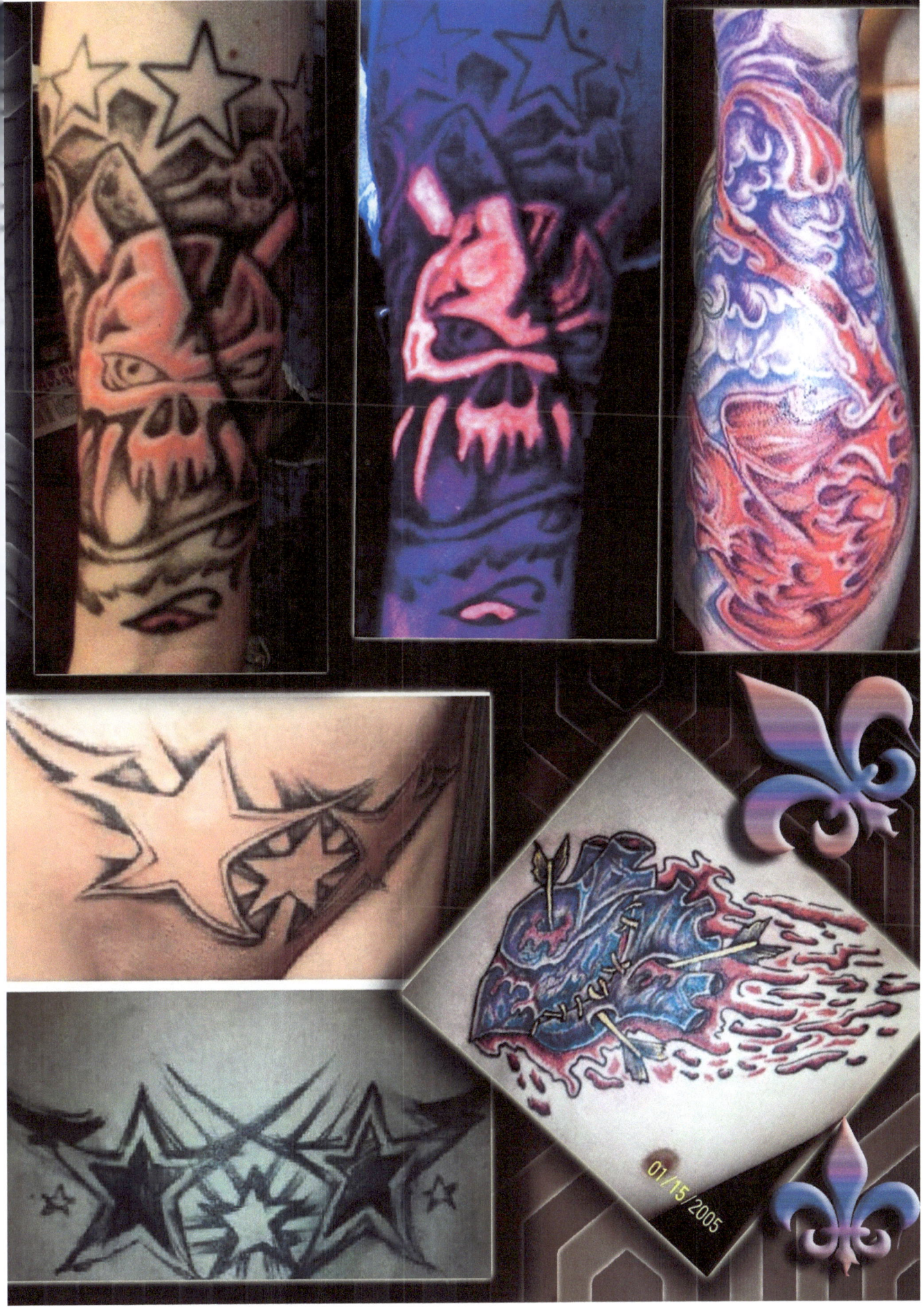

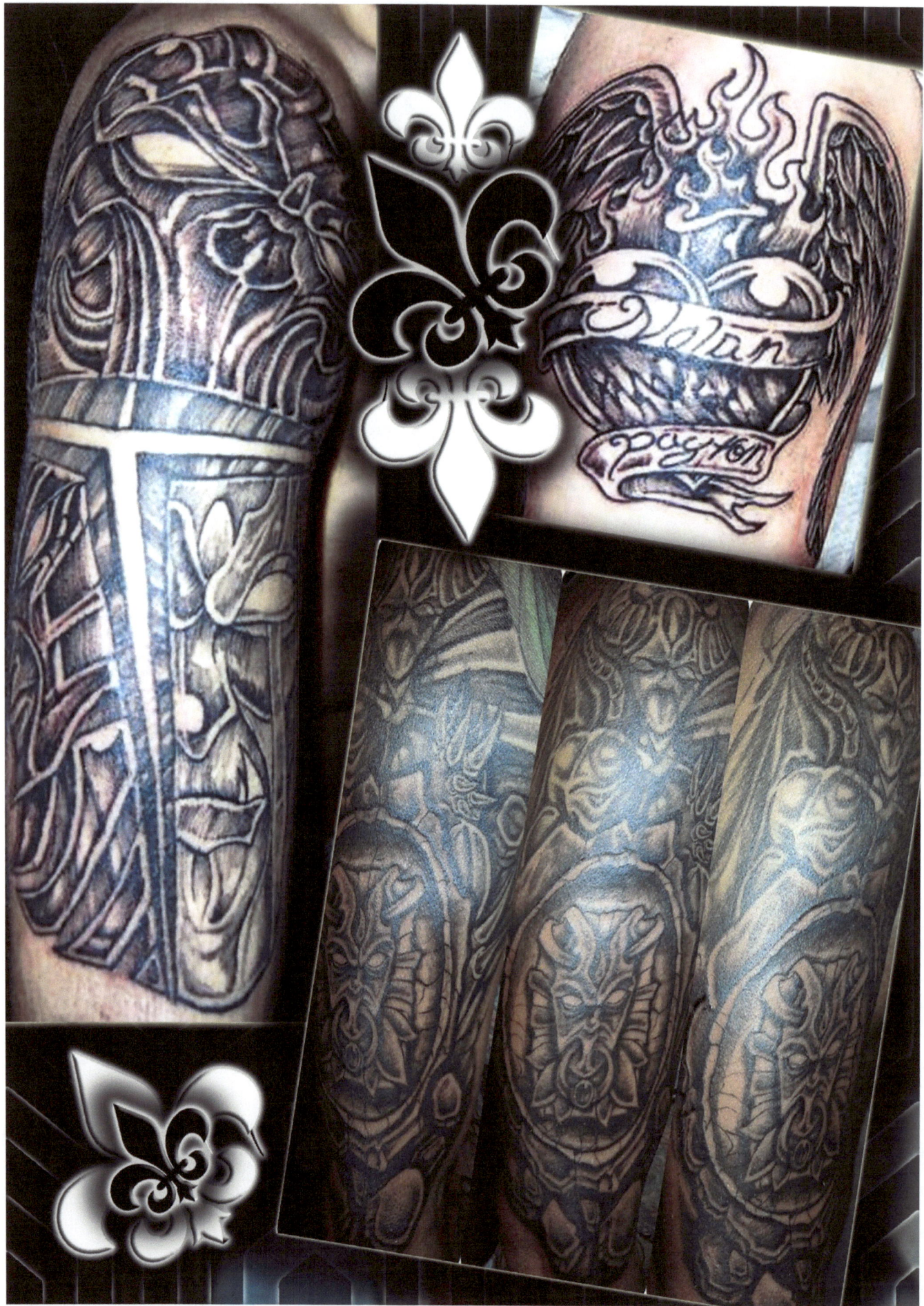

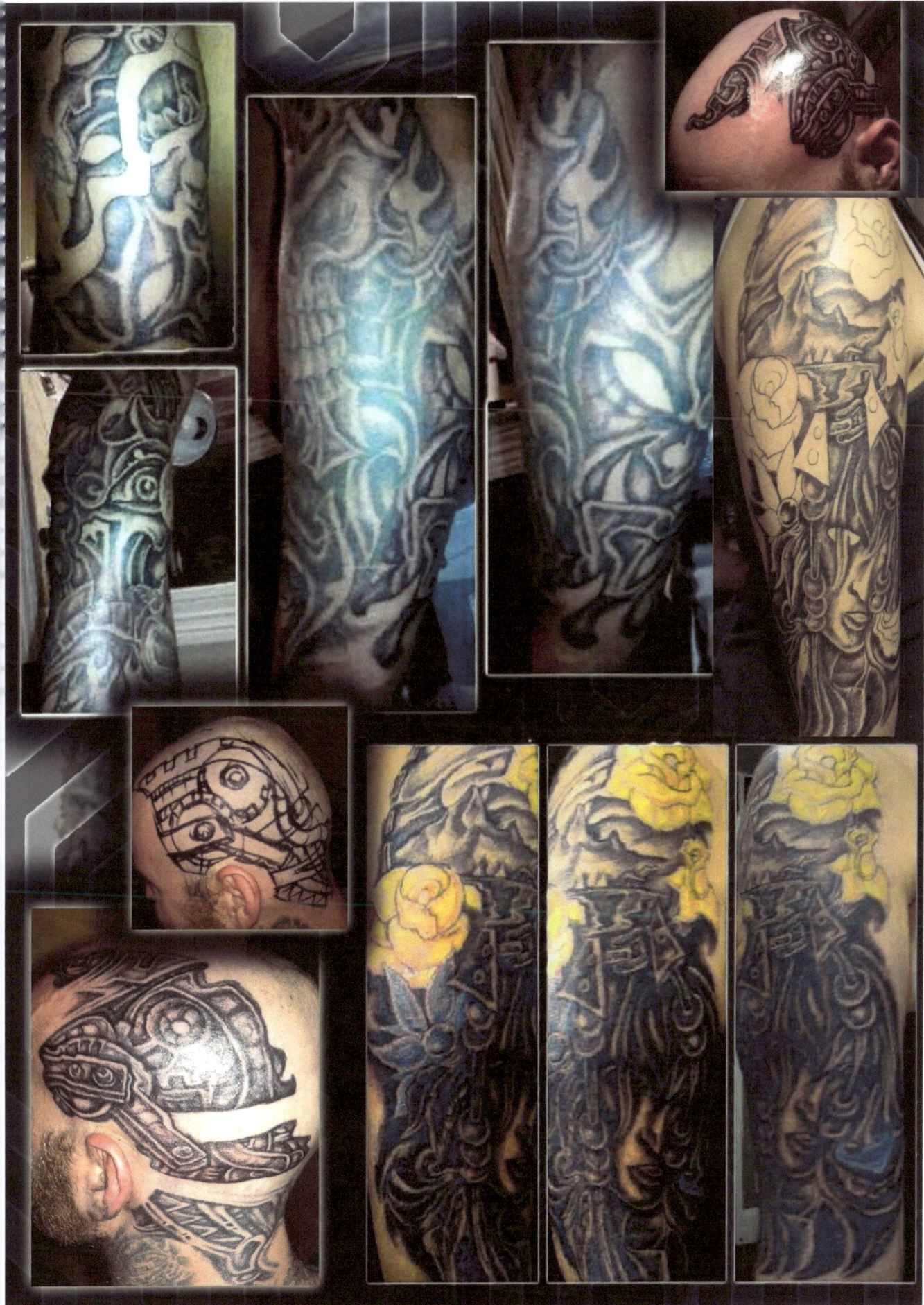

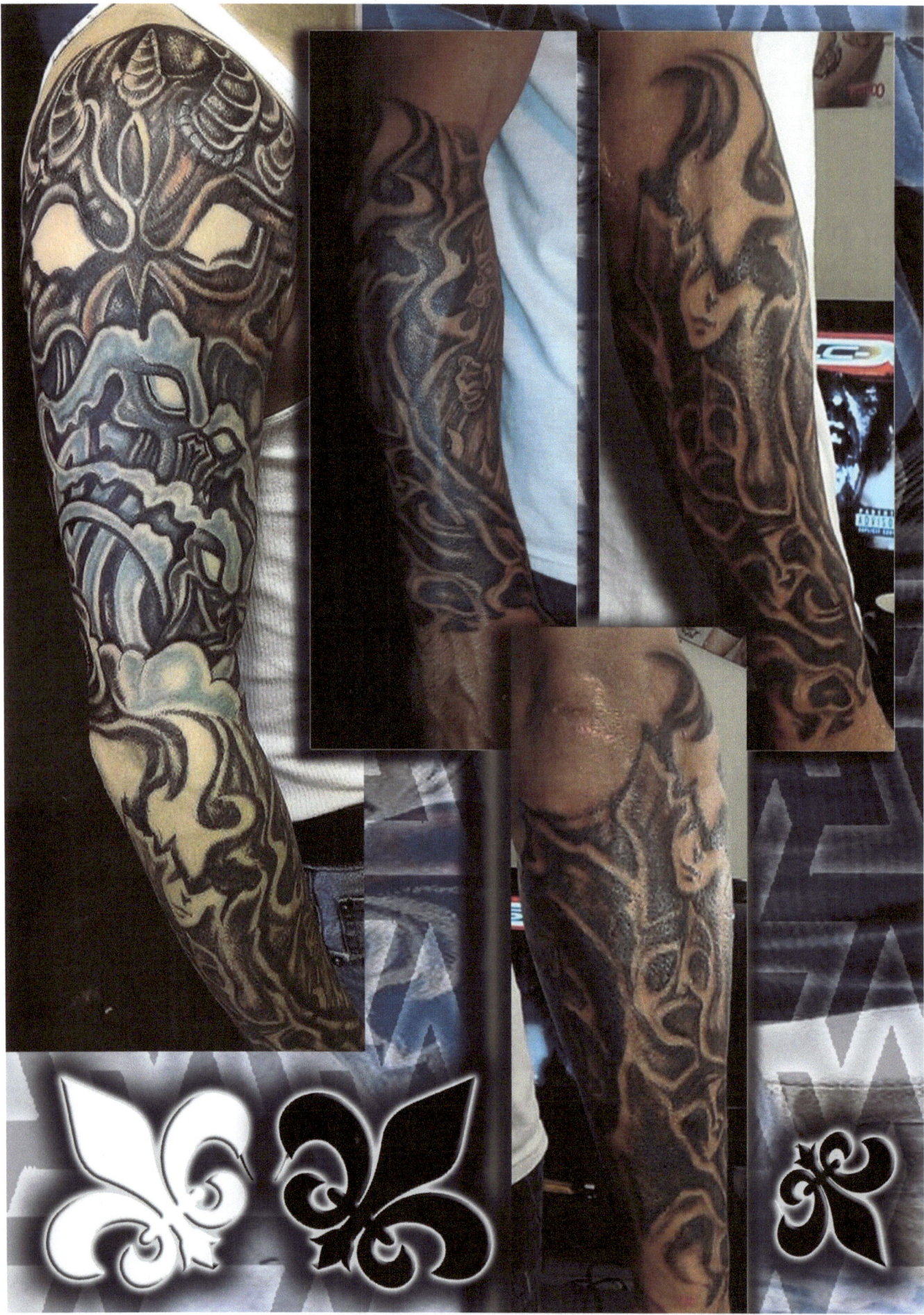

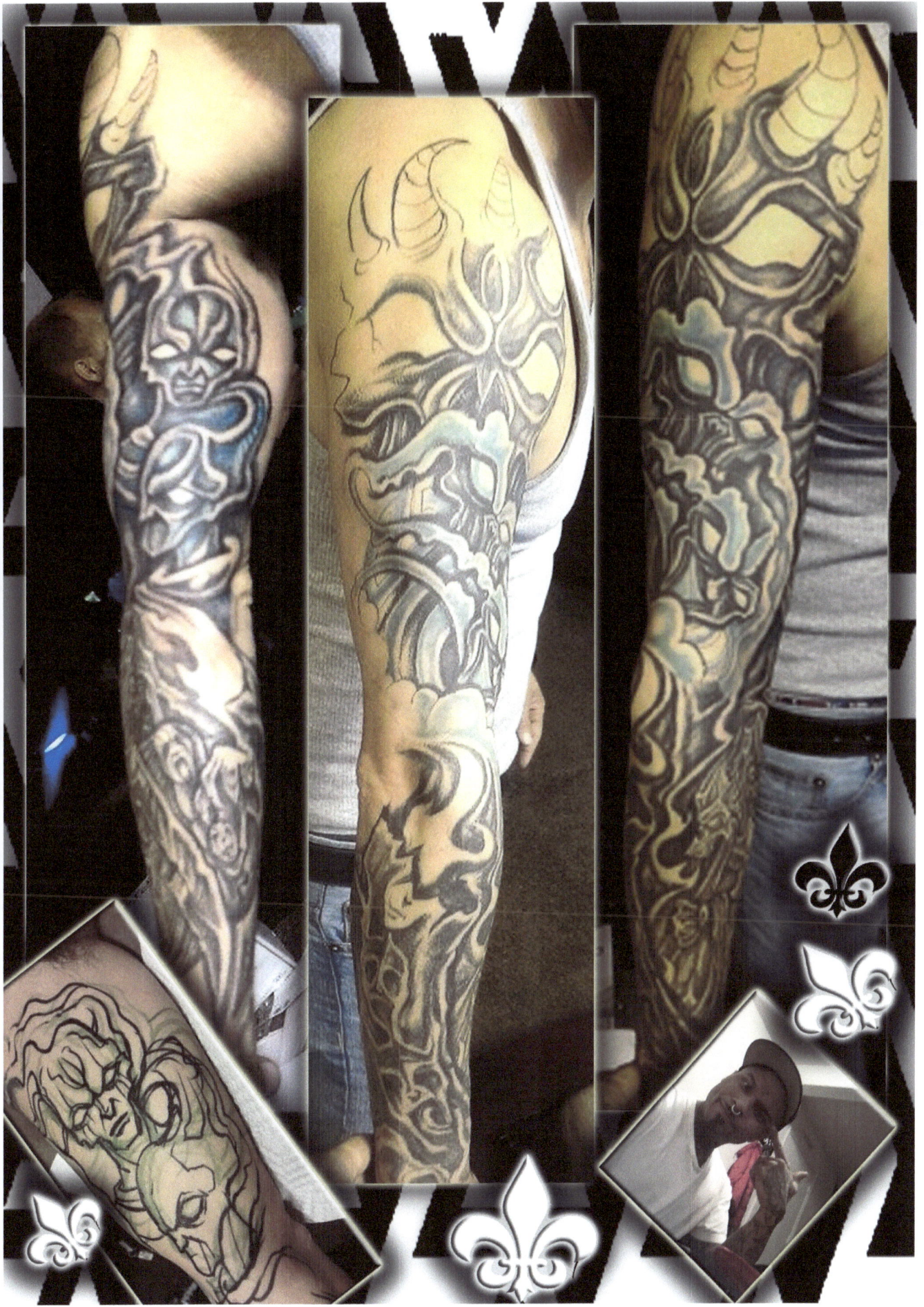

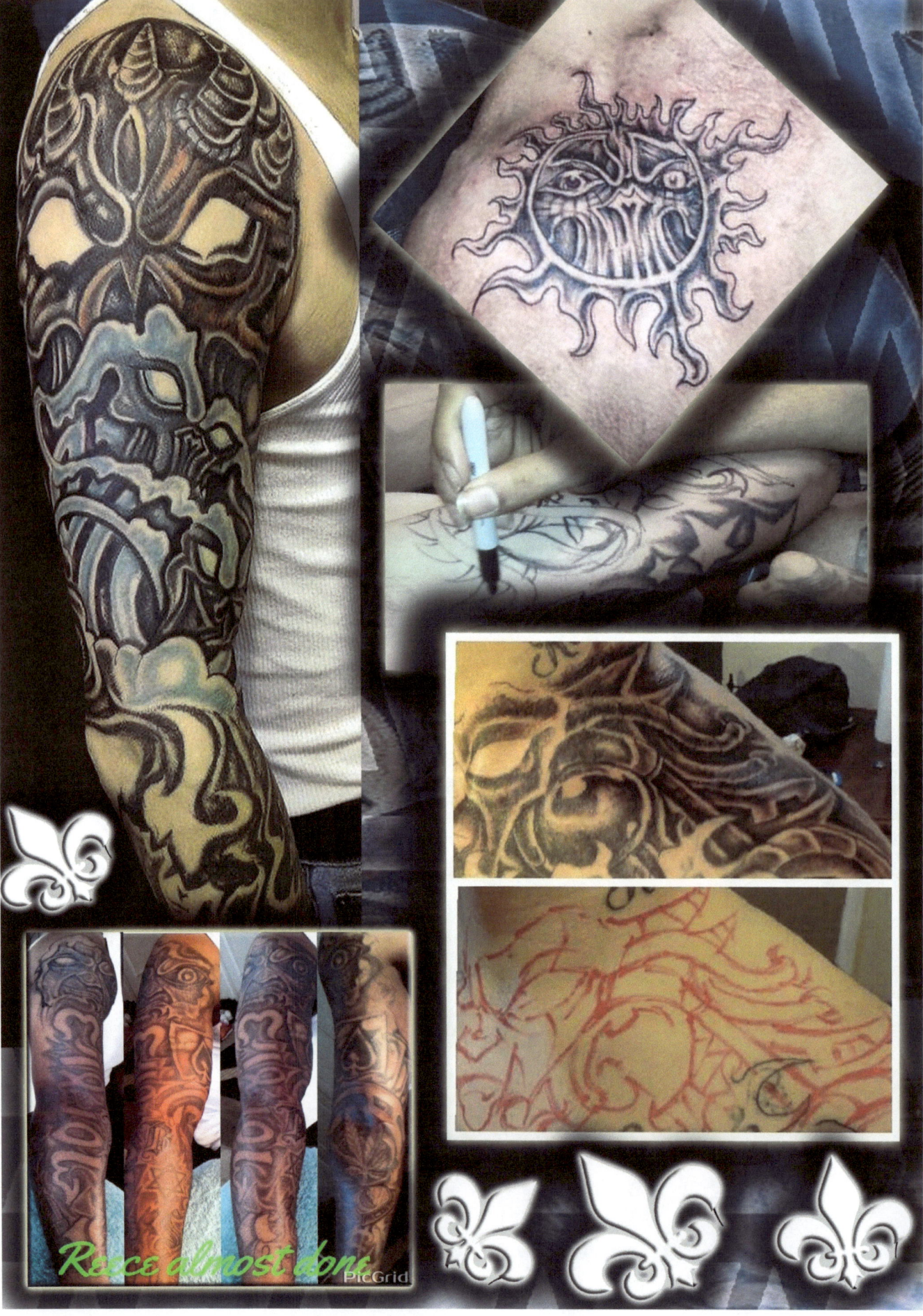

Reece almost done.

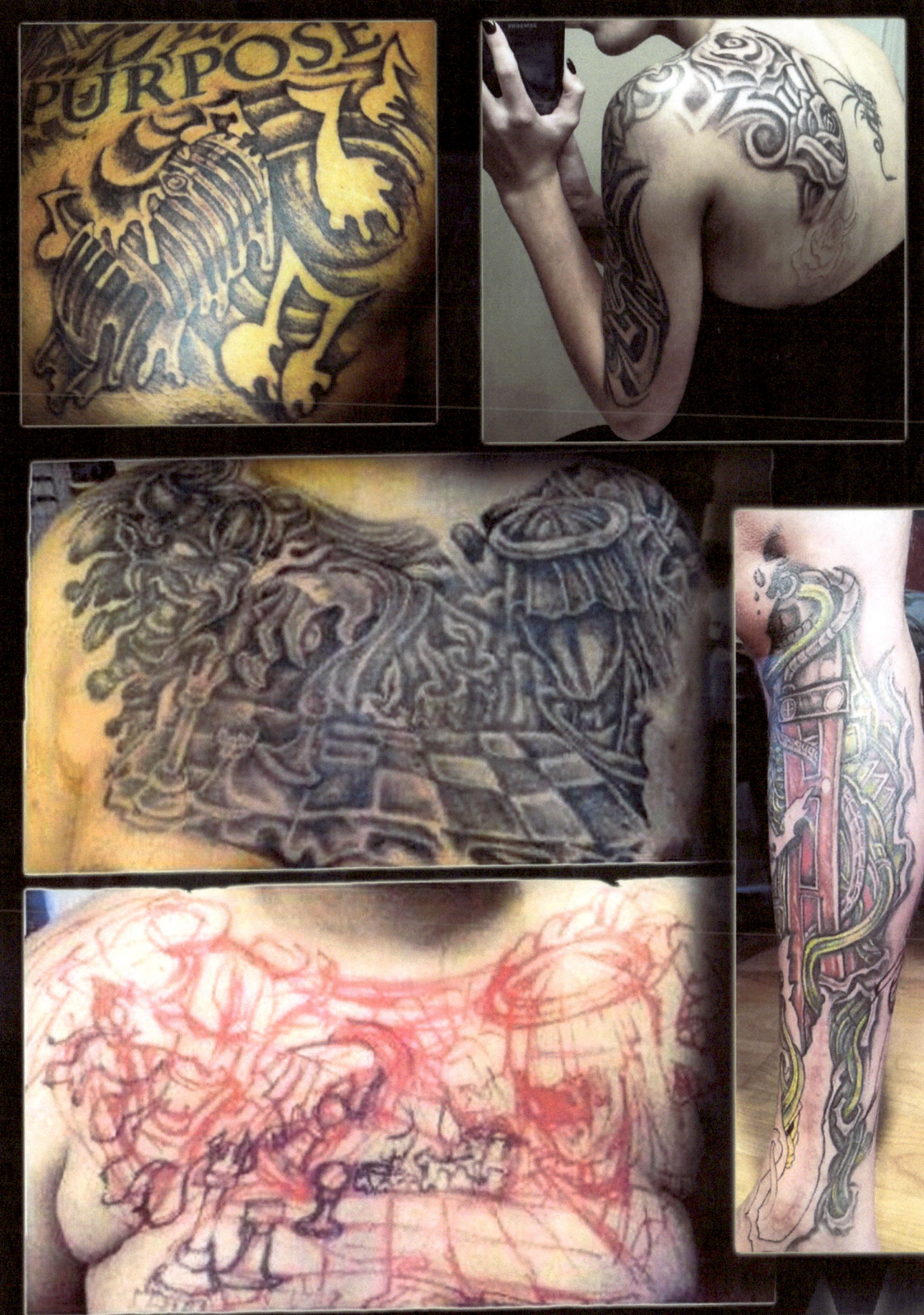

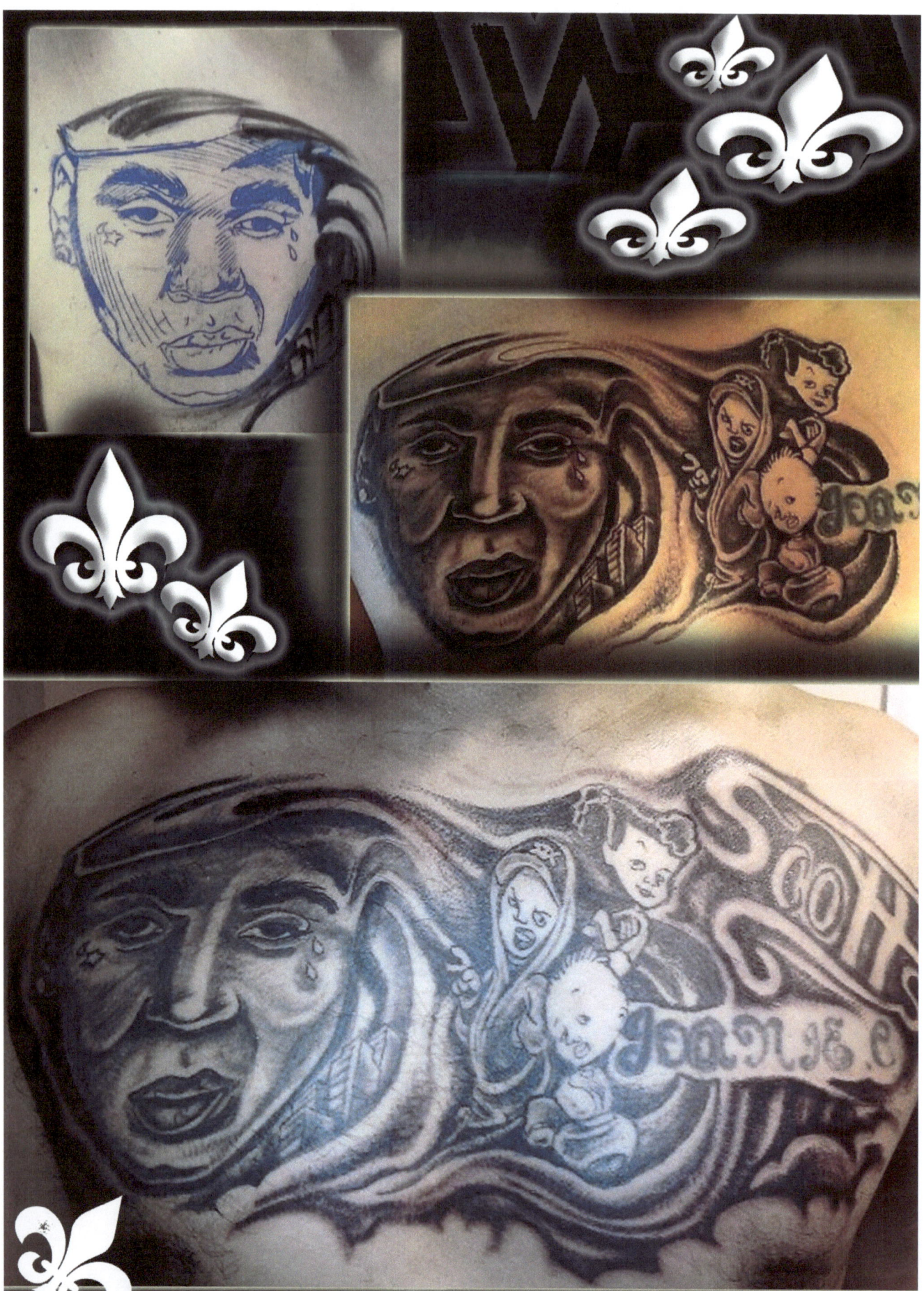

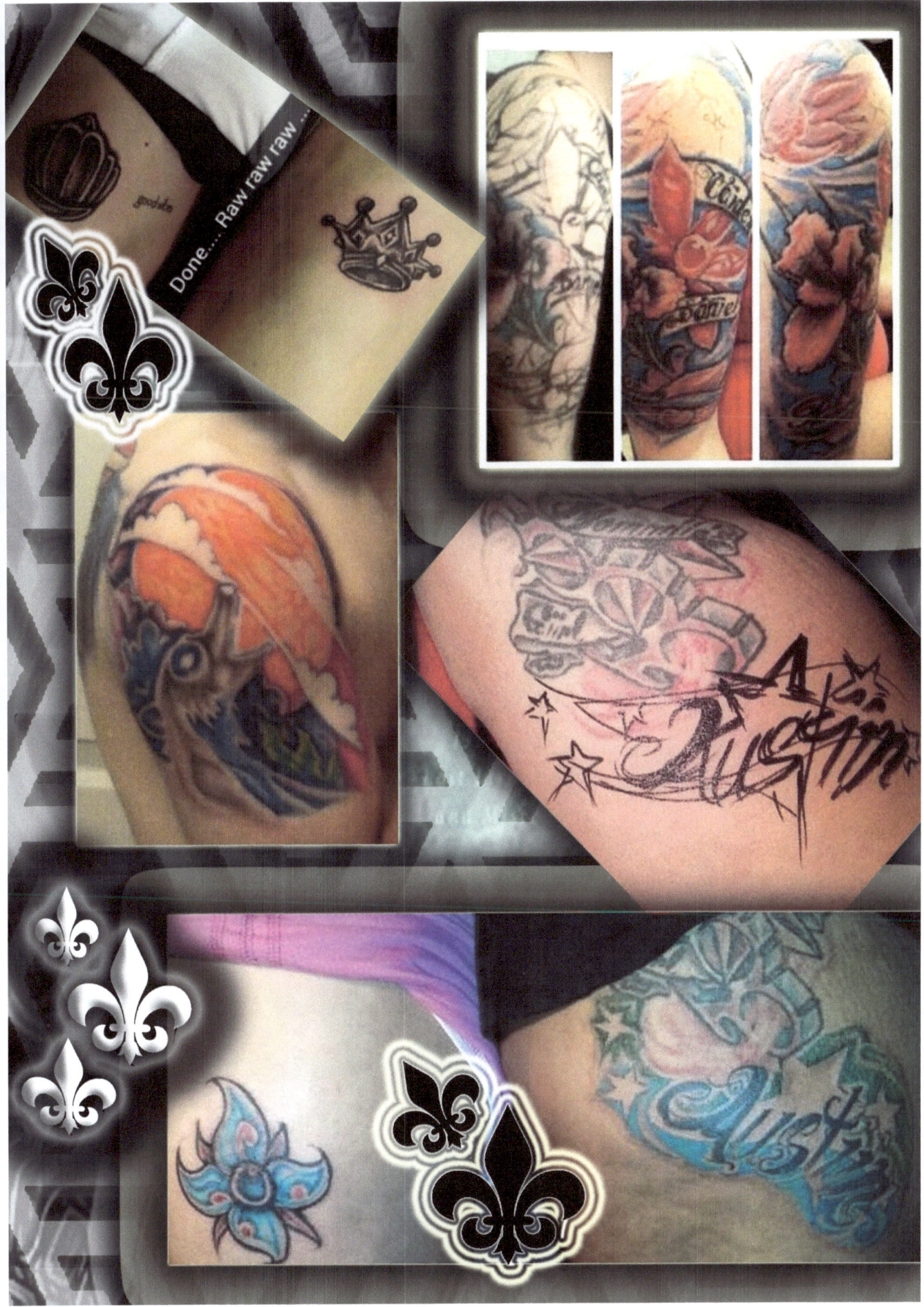

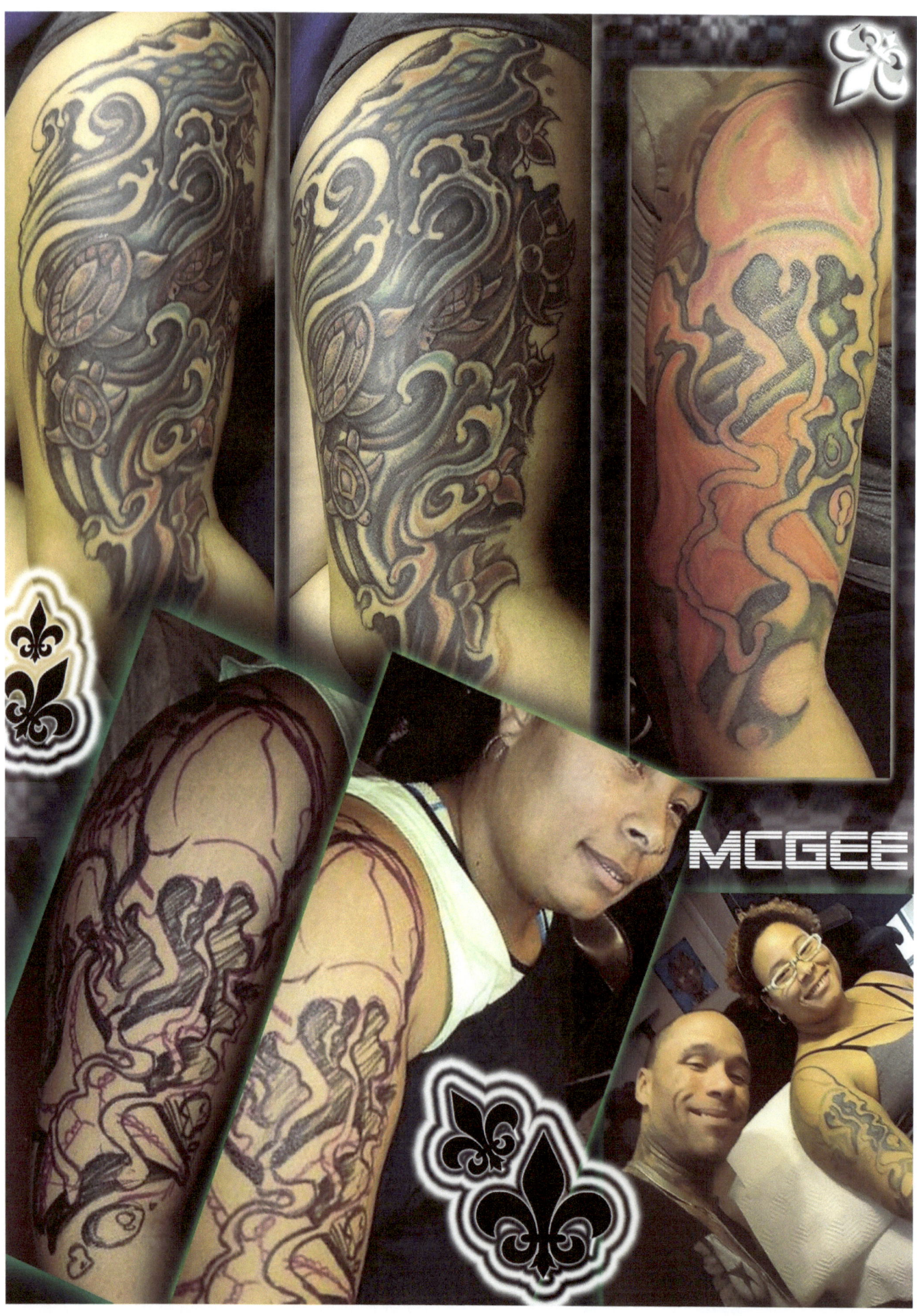

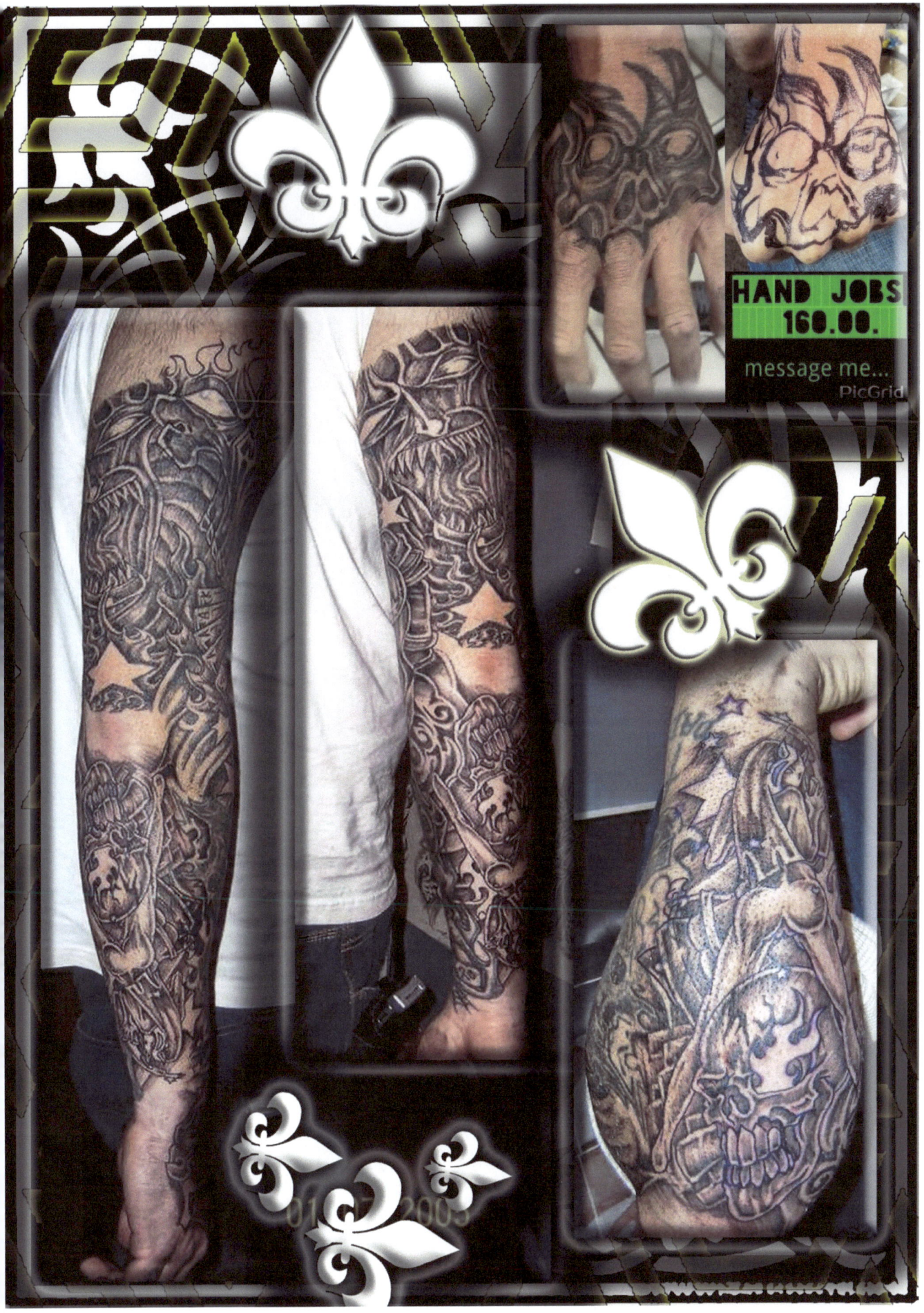

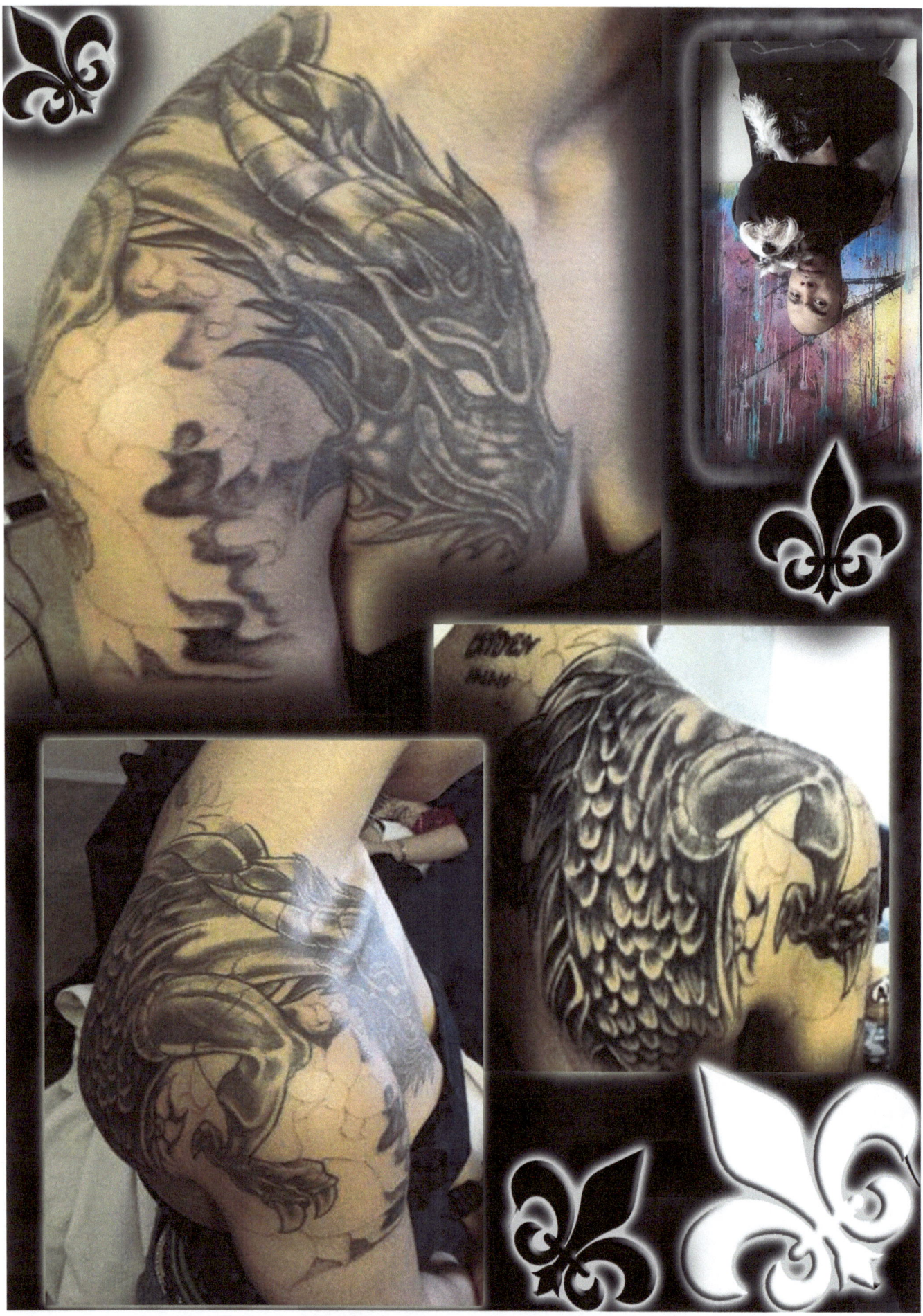

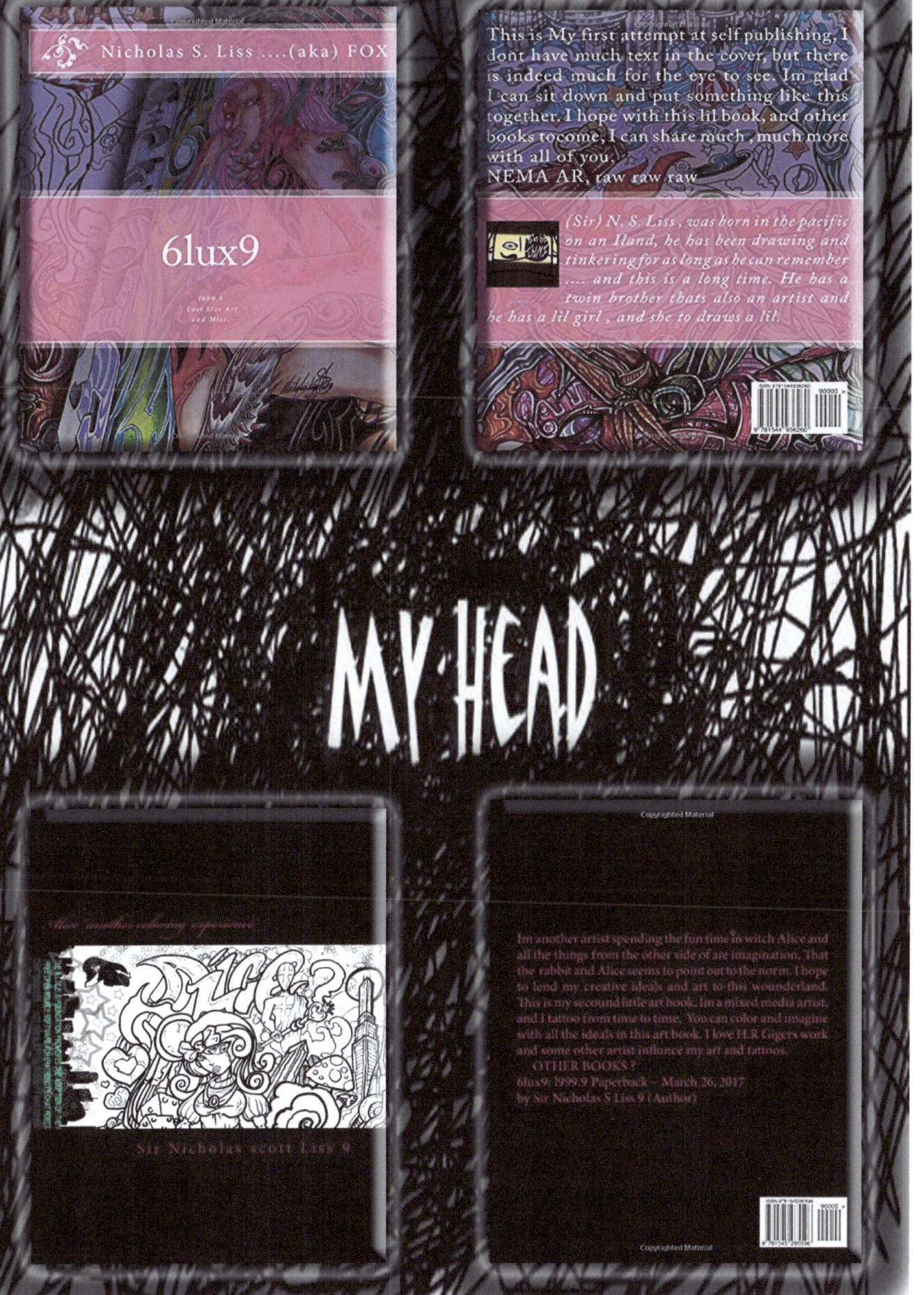

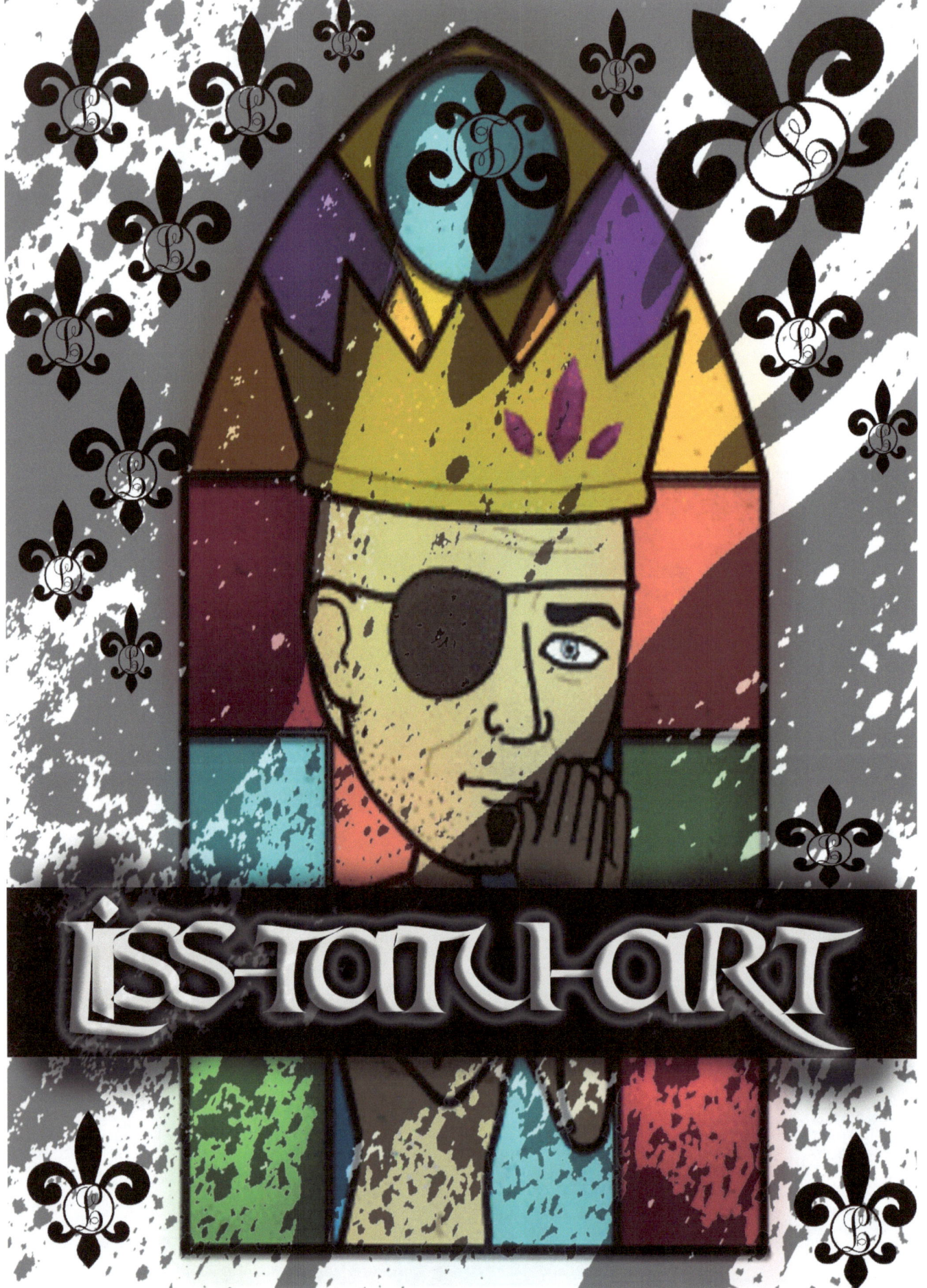